BRANDED?

BRANDED?

GARETH WILLIAMS

V&A PUBLICATIONS

For John Strand

First published by V&A Publications, 2000

V&A Publications
160 Brompton Road
London SW3 1HW

Designed by August Media

Cover photograph by
Elisabeth Scheder-Bieschin
Digital retouching by Nadége
Model: David

ISBN 1851773258

A catalogue record for this book is
available from the British Library

Manufactured in China by Imago

Every effort has been made to seek
permission to reproduce those images
whose copyright does not reside with
the V&A, and we are grateful to the
individuals and institutions who have
assisted in this task. Any omissions are
entirely unintentional, and the details
should be addressed to the publishers.

CONTENTS

ARE YOU BRANDED?

SELFRIDGES&C

What would people think of me if I drove a Mercedes? Am I more 'Gucci' than 'Nike'? Is this the right time to drink a Coke? Our brand choices say a great deal about us as individuals. Brands mean different things to all of us, but how do they acquire those meanings, and who makes them? This short book looks at how brands behave, how they gather associations and references, and what they might mean to the people that buy them.

What is a brand? A brand is a combination of names, slogans, logos, product design, packaging, advertising and marketing that together give particular products or services a physical, recognisable form. But this is not all. Brands also have a cerebral dimension, which is the reputation they enjoy in the minds of consumers. Brands must engender trust and loyalty if they are ultimately to be purchased. A brand, therefore, is a business strategy to encourage us to consume one product over its competitors, and it is a sign loaded with meaning that we choose to consume because we feel we relate to it.

Successful brands are those that achieve a high degree of recognition by consumers. However, it is not enough for a brand to be familiar if we do not internalise its values. McDonald's, for example, is highly recognisable on many high streets, but for its continued success consumers must be persuaded to think of it first, before rivals. A brand needs us to feel an emotional attachment that arises because we regard it as most suitable for us, and because it is best suited to fulfil our particular needs at the moment we encounter it. To help forge this emotional contact brands present themselves to us in different ways; just like people, brands have personalities and characters, and like people they can appear to be different at different times.

Brands offer us a shortcut to buying quality and value. Their reputations are based upon their abilities to deliver us consistent products that fulfil our expectations. When we choose one brand over another, it is because we expect it to live up to our expectations. We may even have formed an emotional attachment to it. All brands make us promises and offer a guarantee of satisfaction. Part of the promise is that the brand seems to have already done much of the leg-work involved in selecting the best quality or value on our behalf. Ideas of quality and value will vary from place to place and time to time. In the supermarket we may seek low prices and maximum quantity. When we shop for more expensive durables, we may be prepared to pay more if we believe one branded product will last longer or work more efficiently than another.

Some brands focus on particular market segments while others try to be all things to all people. Imagine a simple Venn diagram, which is a series of circles with overlapping sectors at the centre. Here, each circle represents a type of behaviour, but brands themselves may be placed in areas of the diagram that are part of two or more circles. It may even be possible for a brand to be placed at the centre, where all the behaviours are represented. The examples illustrated in this book demonstrate a series of characteristic behaviours that we can see in the branding of fashion, lifestyle, and what we may describe generally as 'consumer brands'; that is, the stuff of everyday life in the high street or shopping mall. Most brands are complex entities and the combination of characters mirrors the complexities of consumer responses. But like people, brands often have a predominant character that identifies their personality.

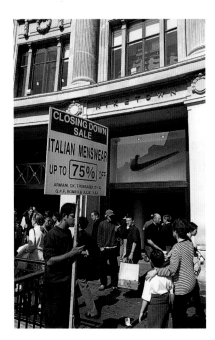

REAL THINGS

Brands that can claim to be the original of their type also lay claim to authenticity. Their products are 'the real thing', and 'the genuine article'. They may want us to feel that originality gives them an edge over competitors, who become by definition 'lookalikes' (and who, by inference, are to be distrusted). Brands that claim authenticity are often also old brands, like Coca Cola and Levi Strauss, and they may reinforce their position by creating mythologies about their own pasts. When we buy the real thing, we are promised a reassurance of quality that comes with authenticity.

THE APPLIANCE OF SCIENCE

We are given a promise of security by brands known for scientific developments, from chemical detergents to the engineering of cars. Their authority gains our trust, and we believe they have thoroughly researched and tested the effectiveness and reliability of their innovations on our behalf. In advertising, this authority is traditionally demonstrated by the 'men in white coats', who show us the benefits of technology. A track record of consumer satisfaction supports the authority of the brand. Elsewhere we find reassurance in service brands like car-recovery associations that promise to know our cars better than we do and to look after us in emergencies.

'EXCESSORIES'

Luxuries promise abundance and sumptuous enjoyment, and are by definition the opposite of necessities. They can be big and expensive, like yachts and cars, or small and inexpensive, like chocolate. We buy luxuries to indulge ourselves by giving ourselves the very best. We may also want luxuries to show the world our status. The sociologist Thorstein Veblen had this in mind when he cited conspicuous consumption of goods by people as a means to establish their place in a social hierarchy. He was writing of the upper classes a century ago, but the same thought could be applied to anyone choosing a highly visible 'premium' brand today.

GET ON AND GET UP

While luxuries are a code undoubtedly used by people to show how wealthy, tasteful and important they feel they are, brands can offer to give us power in other ways. For example we are promised empowerment by information technology and sportswear brands. These brands tell us we can succeed in competition because they will arm us with the tools to survive. Aggressive competition is a motif, and it is therefore not surprising that athletes and entrepreneurs have become heroes in the modern age. Nike, for example, tell us to 'Just Do It™' while selling us the equipment and the image to succeed. These brands promise us a different kind of status based on empowerment.

IRREVERENT AND INDEPENDENT

Brand advertising often employs complex codes that require consumers to decode them. While most brands promise us straightforward benefits, irreverent brands mock the assertions and promises of branding itself. Often an irreverent brand may style itself in opposition to an established brand practice. This is the case with the Italian fashion label Diesel, which mocks the 'all-American' values of Levi's, Wranglers and the rest. We understand the irreverence because we know the original. A brand's non-conformity is a rebellion against convention that we can also buy into.

WONDERLANDS

Particular experiences are sold to us by brands, and some brands offer to enhance all our experiences. Merchandise allows

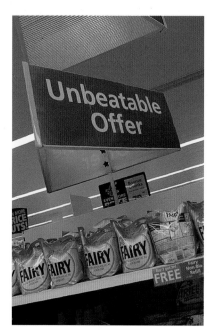

them to spread their values through every part of our lives, often far removed from the original source of the brand. For example, Disney merchandise recalls the films upon which it based but is not part of them; Manchester United merchandise celebrates the football club's successes and reputation without necessarily being about playing the game. These brands share a common character in their 'wonderlands', which are the places consumers can visit to experience the brand undiluted. Disney has its theme parks and Manchester United has the 'Theatre of Dreams' which is its home stadium in Manchester. Another similarity is that they both organise and commercialise our play and recreation. Even leisure is branded.

FUN AND FRIENDLY
Many brands offer to give us a good time, not least those that develop branded characters that appeal specifically to children. The most famous example is Ronald McDonald, whose clown persona is the humanised embodiment of the restaurant chain's values of fun and informality. Often animals are animated and given human attributes to give the brand a friendly face. They make corporations approachable. For children these characters become friends and allies, and gain their allegiance. Consuming, therefore, becomes based upon the human instinct for friendship. Adults may respond to brands that promise to give them social or sexual appeal, like cars and drinks. These brands promise a carefree lifestyle of unrestrained enjoyment.

GUILT AND ANXIETY
In contrast brands may appeal to our consciences, responsibilities and guilt. To do so they may promise to reduce pollution or reverse social injustice. We might feel that our purchase of these

brands is our way of making the world better, and our guilt about our position in the world is alleviated. Arguably, brands that appeal to our sense of responsibility towards each other operate in the same way. We feel guilt about our parenting abilities, for example, so we buy brands that promise to ensure our children's happiness.

GLOBALLY LOCAL
In Western culture undeniably we use brands as one way to define and express our identities, but the success of capitalist economies that support and underlie brands means that they are global forces. Some international brands maintain a consistent message all over the world; others adapt to fit into locally specific cultures. As a symptom of culture defined by consumption, brands have been identified with American values, and most global brands are American in origin. But brands from other parts of the world do not simply assimilate American culture. Increasingly non-Western brands are developing as expressions of non-Western cultural identity.

The examples of brand behaviours that follow are not intended to be definitive. All brands show different behaviours and character traits. These examples were selected to show the breadth of brands' activities and the different ways they embody their values – in their products, logos, advertising and other strategies. But to succeed, brands must trigger an emotional response in the mind of the consumer by appearing to fit the environment where they are encountered. Brands and their meanings are formed as much by consumers as they are in the boardrooms of marketing executives, on the computer monitors of product designers, or in the television studios of advertisers.

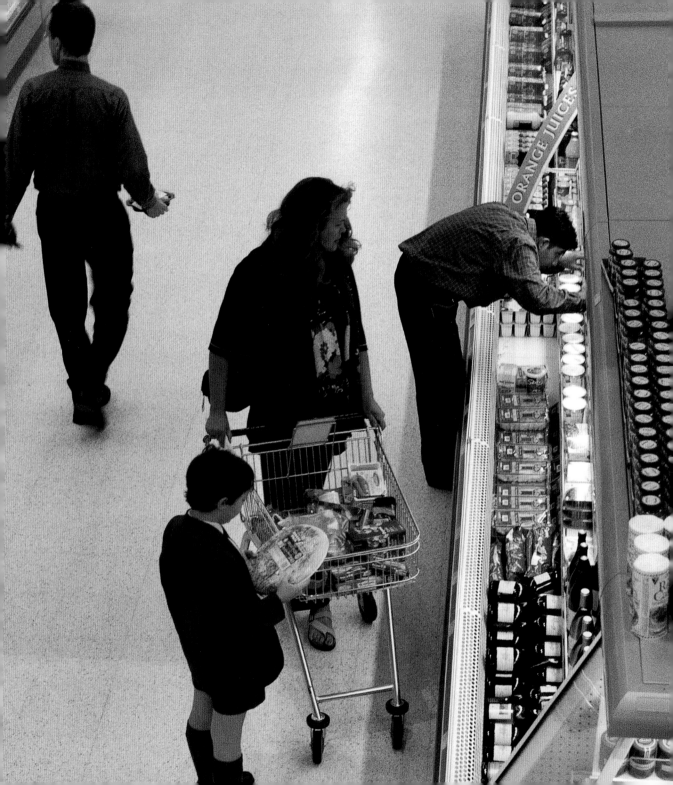

Levi Strauss

Several brands of denim workwear claim to be the oldest yet Levi Strauss & Co., founded in San Francisco in 1853, has secured the role of 'original' jeans makers.

Levi's history is written into the actual fabric of each pair of jeans. The Two Horse label represents a (probably fictional) nineteenth-century promotional stunt, where a pair of Levi's jeans was stretched between two horses that expired before the jeans split. The seam-strengthening rivet was introduced in the 1880s and refined in the 1930s so it no longer scratched seats and saddles. Even the introduction of the orange thread and the double stitching can be dated and accounted for. Each detail indicates the strength and workmanlike value for money of Levi's jeans.

Against this functional imagery, how did jeans become associated with the ephemeral world of fashion? Levi's has created a mythology of its own past, placing itself at the heart of the American Dream. From the early twentieth century Levi's appropriated cowboy and Wild West imagery, claiming pioneering territory from rivals such as Wrangler. By conquering America's frontier, Levi's became a symbol of America itself. And in a world increasingly dominated by American values and imagery, Levi's jeans became synonymous with the freedom and possibilities of America. Jeans are the most democratic of all attire, the uniform of the masses. Moreover, jeans are unisex. Each pair of jeans is genetically ('jean-etically') connected to American values and we see each pair of jeans – whoever made them – as the offspring of Levi's.

© Levi Strauss & Co., San Francisco.
Courtesy Levi Strauss & Co. Archives, San Francisco

Levi's has created a mythology of its own past, placing itself at the heart of the American Dream.

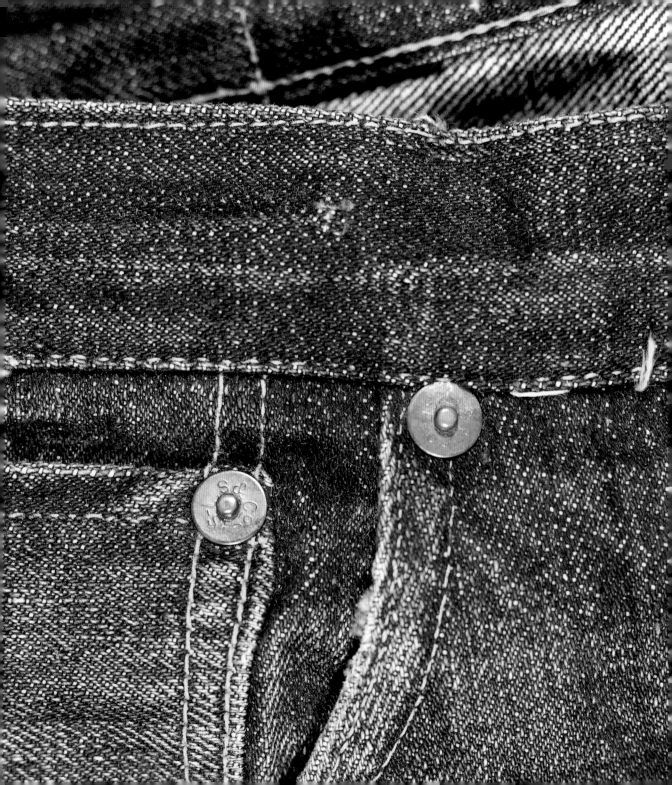

Coca-Cola

The most recognised brand in the world is also the most democratic. Coca-Cola makes one basic product, with variations, that appeals to people across age, class, gender, race and income. As Andy Warhol observed in 1975, 'You can be watching TV and see Coca-Cola and you can know that the President drinks Coke, Liz Taylor drinks Coke, and just think, you can drink Coke too. A Coke is a Coke and no amount of money can get you a better Coke than the one the bum on the corner is drinking. Liz Taylor knows it, the President knows it, the bum knows it and you know it.'

The Coca-Cola bottle was designed to make it stand out amongst competitors. It is one of the most recognised symbols in the world, probably due to the vast numbers that have been produced (the company estimates that it has made more than 840 billion glass bottles). The bottle shape, introduced in 1915, is a registered trademark of Coca-Cola, acknowledging the significance of the packaging design to the success of the brand. The Coca-Cola script logo may be older, but the bottle shape is just as significant as a vehicle for the brand's values: it has become a logo itself.

The vast majority of Coca-Cola is sold today in cans, but the heritage of the contour bottle persists in the graphic design of the packaging. There is comfort in consuming a familiar brand and many of us recall drinking Coke from such a bottle. Recognising this, the company reissued glass bottles to British supermarkets in 1999. The shape of the bottle is also seen in Coca-Cola graphics – a visual reminder of the brand's origins.

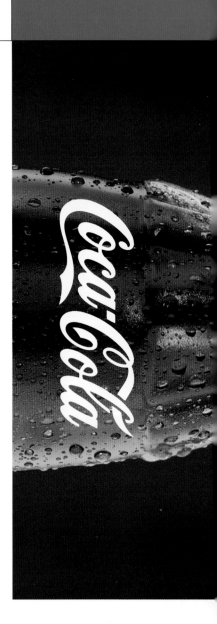

Coca-Cola graphics, 2000
Coca-Cola, Coke, and the design of the Coca-Cola Contour bottle are registered trademarks of The Coca-Cola Company.

A brand can be
mistaken as the
generic name for
the product.

Rollerblade

Trademarks distinguish brands from their competitors
and legally protect famous names from being used by
rivals. If a brand is the first to succeed in its product area
its name can become the generic name for the product
itself. In one sense this is a sign that the brand owner
has succeeded in building relationships with consumers
who have thoroughly internalised the brand. On the
other hand, becoming the generic name for a product
type can devalue the brand as the name becomes
symbolically attached to rivals and looses the specificity
that defined it as a trademark in the first place.

This is the experience of well-established brands
like Hoover, Sellotape, Biro and Thermos. While we
might expect old, familiar brands to become generic
descriptors of their product type, Rollerblade® shows
that this process can happen to a relatively young
brand too.

In-line skates were developed in the early 1980s as
off-season training equipment for ice hockey players,
but by the end of the decade Rollerblade®, the best
known in-line skate manufacturer, had popularised
skating as general recreation as well as sports training.
Because the brand is so identified with the activity it
is difficult for Rollerblade® to resist consumers viewing
it as the generic name for in-line skating.

© Rollerblade

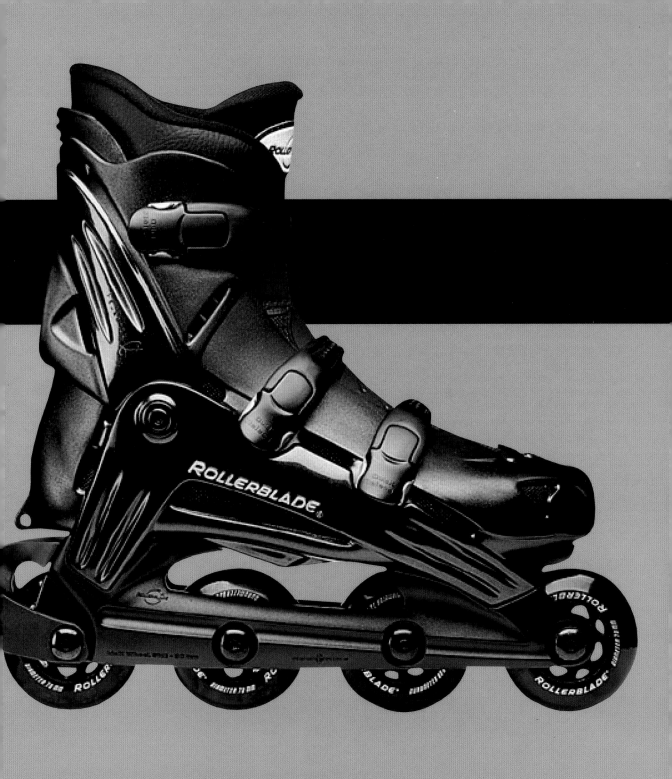

Heinz

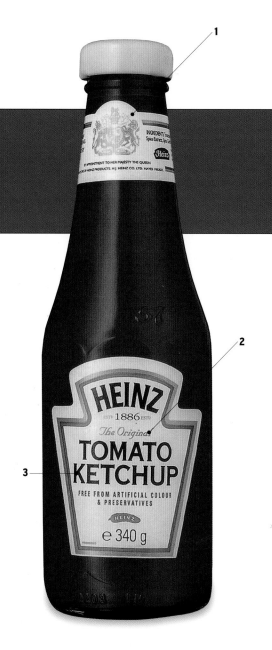

Heinz is one of the oldest and most famous food brands, specialising in canned and bottled foods. Its proud heritage is made explicit on its packaging. The glass and plastic bottles shown here demonstrate a recent change in style. Specific British references have been played down in order for the bottles to be sold all over the world.

1. The crest shows that Heinz has a Royal Warrant to supply the British royal household – an assurance of quality. The bottles with the Royal Warrant, designed specifically for the British market, have been superseded by a generic, international identity.

2. Heinz Tomato Ketchup was first produced in Pittsburgh in 1876.

3. Ketchup was originally called Catsup, derived from the Cantonese Koe (tomato) and chiap (sauce).

4. Heinz first began making food products in 1869. In 1886 London's most distinguished grocery, Fortnum & Mason, was the first British store to stock the product.

5. There are many more than 57 varieties of Heinz products, but this early marketing claim became so famous it is still used.

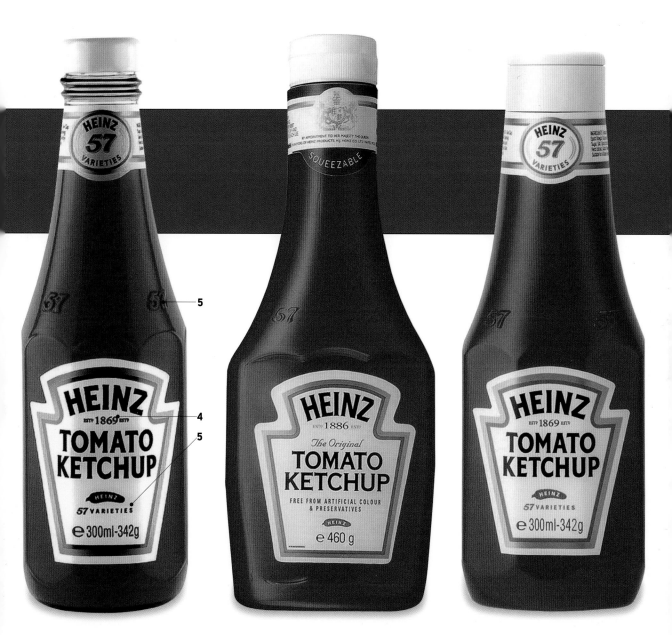

AA
(Automobile Association)

There are products and services we only use when we are in trouble, or to reassure ourselves we will be safe. The Automobile Association is just such a service that sells British motorists peace of mind. The AA has existed since 1905 - almost as long as the motorcar itself - providing drivers with roadside assistance when their cars break down. The distinctive yellow and black livery of the recovery vehicles makes them seem like ambulances for automobiles, and the uniformed mechanics are like paramedics. Since 1993 the Automobile Association has dubbed itself 'the 4th Emergency Service', suggesting its alignment to the official police, ambulance and fire brigades. However, the lifeboat rescue service also views itself as the fourth emergency service.

Officially an emergency service or not, the AA is a brand imbued with the authority and expertise to look after us when we need care. Drivers trust it because it has a long history of customer satisfaction and it appears reliable and dependable.

© The Automobile Association/Andrew Thomas 1997

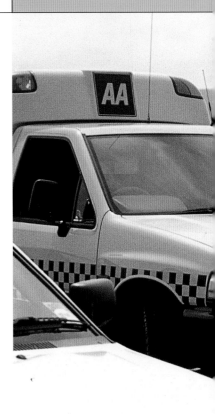

Ambulances for automobiles.

Mr Clean

Mr Clean's advertising jingle suggests his reliability and versatility:

Mr Clean gets rid of dirt and grime
and grease in just a minute – Mr Clean
will clean your whole house and
everything that's in it.
Floors, doors, walls, halls
White sidewall tyres and old golf
balls, sinks, stoves, bathtubs he'll do.
He'll even help clean laundry too!
Mr Clean gets rid of dirt and grime
and grease in just a minute – Mr Clean
will clean your whole house and
everything that's in it.
Can he clean a kitchen sink?
Quicker than a wink!
Can he clean a window sash?
Quicker than a flash!
Can he clean a dirty mirror?
He'll make it bright and cleaner!
Can he clean a diamond ring?
Mr Clean cleans anything!

Procter & Gamble introduced Mr Clean in 1958 to give American housewives a helping hand. The prefix 'Mr' was popular in the late 1950s to describe the embodiment of a particular trait (for example, Milton Berle was known as Mr Television). Mr Clean's persona was based on a rugged sailor whose masculine strength would be an asset around the house, at a time when gender roles assigned most housework to women. In Mr Clean the reliable, trustworthy brand message is relayed forcefully to the consumer, laced with sexual flirtatiousness. He has become an institution in the USA, but Mr Clean is less well-known elsewhere. In the UK Procter & Gamble market the same formula cleaning fluids as Flash.

Mr Clean advertisement 1997
Reprinted with permission of The Procter & Gamble Company

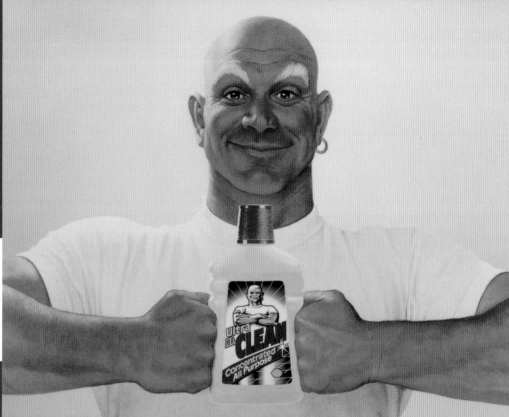

Easier cleaning tip:

Use somebody else's muscle.

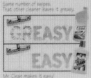

Same number of swipes.
That other cleaner leaves it greasy.

GREASY

EASY

Mr. Clean makes it easy!

That other cleaner's making you work harder than you have to.
Mr. Clean's concentrated formula penetrates and dissolves
tough greasy dirt on contact. Put him to work all over your house—
from greasy stovetops to sticky counters to grimy floors.
No matter how tough the job, he makes cleaning a snap!

Tougher on dirt. Easier on you.

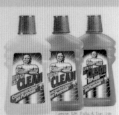

Lemon, Mt. Falls & Spring Job

Bold a., adv., & n.
Courageous, enterprising, confident, stout-hearted; daring, brave.

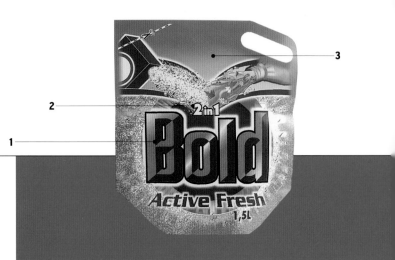

Bold

1. **Bold** a., adv., & n. 1. Courageous, enterprising, confident, stout-hearted; daring, brave.
2. Presumptuous, forward, immodest. 3. Strong, big.
4. Certain, sure (of), trusting (in). 5. Striking, well marked, clear; free or vigorous in conception etc. (OED)
2. Efficiency and convenience are assured. It washes and conditions, without the need for separate substances or measures.
3. Bold is made as powder and as liquid. Although they are entirely different substances, their uniform performance is assured through identical packaging for both.
4. The conditioner is packed with natural freshness. Although we do not expect actual flowers in it, we are told the essence of nature is harnessed within.
5. The washing powder appears magical, like stardust. We are not told how it works, but its brilliance leads us to trust its cleaning ability.
6. The bubbles are more suggestive of sparkling wine than of the foam that is actually created. The image is active, almost festive, rather than functional and chemical. Is Bold the 'champagne' of detergents?
7. Bright colours and large graphics make sure we see the brand amongst jostling competitors on the supermarket shelf.

Bold liquid, above, and washing powder, oppposite, Procter & Gamble, 1999.
© Procter & Gamble/Picture Disc.

2 in 1

Bold

Active Fresh

10

www.washright.com

Mercedes-Benz

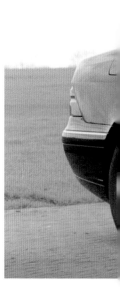

It is often suggested that cars are extensions of their drivers' personalities, so is it significant that the most frequent choice of new car for lottery winners in Britain is a Mercedes-Benz? Perhaps this car represents the ultimate personal indulgence and the winners' aspirations. It speaks of taste, comfort, speed and solidity. It tells the world the driver has (in every sense) 'arrived', and it is shorthand for success. Executives, royalty and presidents travel by Mercedes, so why shouldn't the (lowly) lottery winner?

Mercedes-Benz is one of the world's oldest automobile brands, originating with Karl Benz's Patent Motor Car in 1886. The company's investment in technology and design reinforces its reputation amongst drivers. The latest gadgets – from automatic instruments to heated seats and on-board navigational computers – cater for every real and imagined need. But rather than appearing soft and seductive, the luxurious plethora of equipment in a Mercedes-Benz is styled to emphasise its engineered brilliance. Even the satisfying 'clunk' of the door is attended to. Too heavy and the car appears leaden; too light and it will appear flimsy. To own a Mercedes-Benz, therefore, is to own the automobile equivalent of a Swiss watch, or a helicopter.

This image associates the top-of-the-range S class car with a chopper that is both its corollary in terms of engineered excellence and in terms of its status as a rich man's plaything.

Mercedes-Benz S500L, 1999
© Reproduced with the kind permission
of DaimlerChrysler UK Ltd.

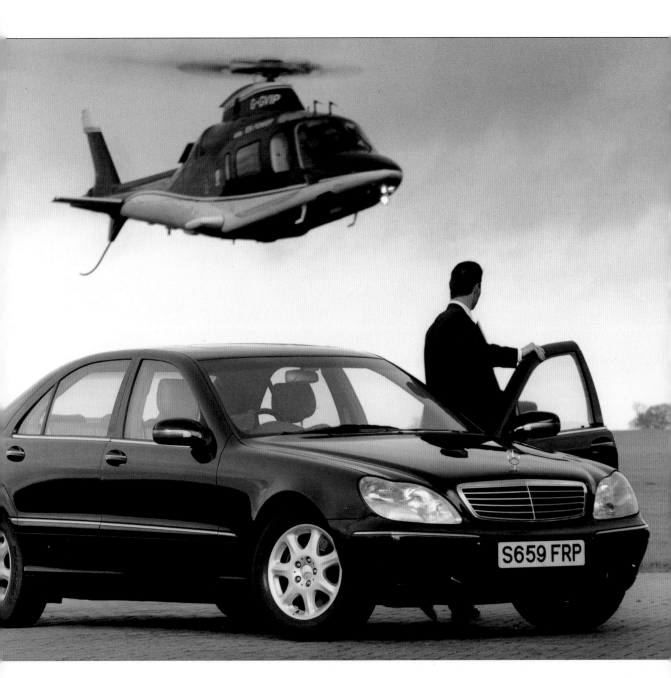

Muji

Muji, the Japanese brand of food, homewares, clothing and furniture, claims to be 'all value no frills' – in fact, to have no brand at all. It gains authority and our respect by appearing not to mask inferior products behind elaborate packaging or advertising hype.

Minimally packaged foodstuffs in the early 1980s set Muji products apart from the excessive packaging characterising many Japanese products since the 1970s. Now all Muji products share a simple, minimalist presentation. In Muji stores they seem to be 'staples' of modern living, almost fundamental archetypes.

Muji Cola brings these values to the crowded soft drinks market where the similarity of products makes it difficult for brands to differentiate themselves. For colas the problem is compounded by the dominant presence of the market leader, Coca-Cola, against which competitors are principally defined as 'not Coke' and only secondarily by their various character traits. Muji Cola does not refer to Coca-Cola in its packaging (apart from the choice of can as a container). In place of the script lettering, photographic condensation; bubbles and 'fun and fizzy' imagery employed by other brands, the cola sticks to the formula used consistently across all Muji products, from food to futons, cutlery and clothing. The lettering, predominantly in Japanese, appears almost medicinal, or like a service statement. Muji is seriously stylish, appealing to fashion-conscious readers of lifestyle magazines and Sunday supplements.

The first British Muji store opened in Carnaby Street in 1991. Imported goods can often have added kudos and while reductive minimalism has been a fashionable style, Muji's no-brand stance has found a market eager for simplification.

Muji Cola
© Ryokin Keikaku Co. Ltd.

Gucci

The reputation of the brand is carried almost exclusively by the logo.

What is the relationship between the brand and the product? With this example, does the logo in the buckle indicate the quality of the leather, or is the belt itself a mount to display the logo? Is the consumer buying high-quality craftsmanship, or a desirable and highly recognisable symbol?

Gucci's reputation is built upon the quality of the leather goods that have been the basis of its product range since 1923. Today, leather accessories, luggage and shoes are produced by master craftsmen in Italy under strict quality controls. Gucci products remain highly sought-after indicators of a sophisticated fashion sensibility, and the Gucci brand is an assurance of quality to the consumer.

However, the brand name is now arguably more potent and desirable than the actual products. This simple leather belt, however well made it may be, has added value and kudos for the consumer because of the Gucci moniker, which is displayed prominently for others to see. The quality of materials and craftsmanship is bound up in the reputation of the brand but carried almost exclusively by the logo, which becomes the sole decoration on the product.

Gucci black belt with silver G clasp, Spring/Summer 1996
© Gucci/Raymond Meier.

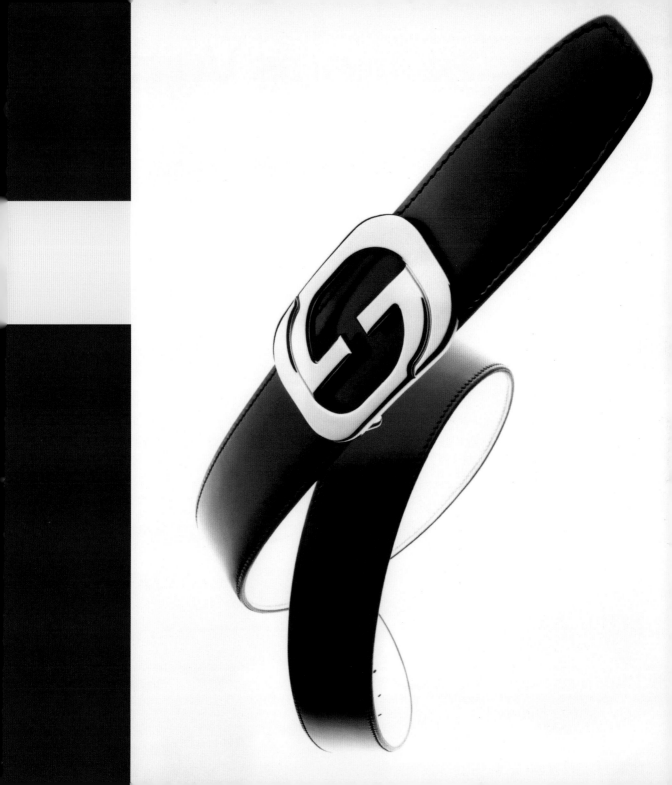

Louis Vuitton

Louis Vuitton is one of the premier global luxury brands, with an image built upon the accoutrements of luxury travel.

Images of the Orient Express, transatlantic steamships, villas on the Riviera and 'a room with a view' are conjured up by luggage that speaks of a 'golden era' of travel. The journey itself was part of the great experience. First Class meant more than extra leg room, and one stayed for the season, not just a fortnight.

The portable wardrobe may be anachronistic in Heathrow or LAX today, but it remains a potent image of exclusivity and status from the past. The 'keepall' bag is more suited to the democracy of modern travel but continues the visual language: the LV monogram is an instant indicator of refinement and taste, the gold embossing and leather speak of craftsmanship and quality. These are values recognised world-wide, and are a code carried and worn by luxury-lovers and status-seekers everywhere. Such is the recognition of, and demand for Louis Vuitton that it tempts fakers and counterfeiters to make street corner knock-offs from Milan to Manila.

Louis Vuitton is one of the premier global luxury brands, with an image built upon the accoutrements of luxury travel in the early part of the twentieth century. Luxury and style have long been associated with French products, and the French conglomerate LVMH, of which Louis Vuitton is the centrepiece, includes the famous exclusive brands of Moët champagne and Hennessy cognac alongside grand fashion labels Givenchy and Lacroix.

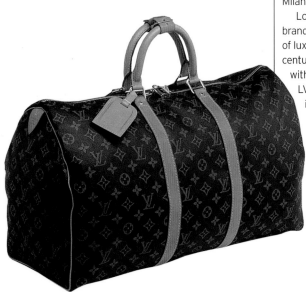

Right: Louis Vuitton 'wardrobe' in monogram canvas
© Louis Vuitton
Left: Louis Vuitton 'keepall' in monogram canvas
© Louis Vuitton

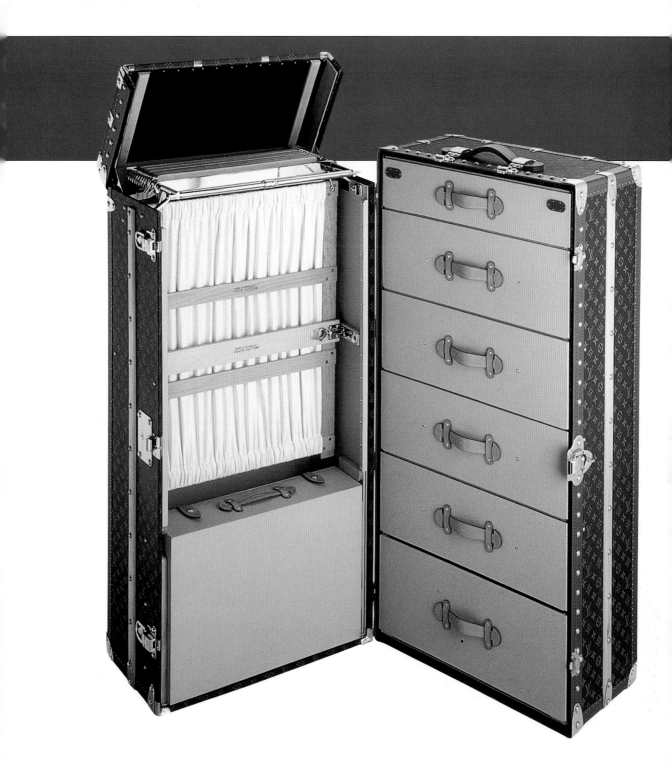

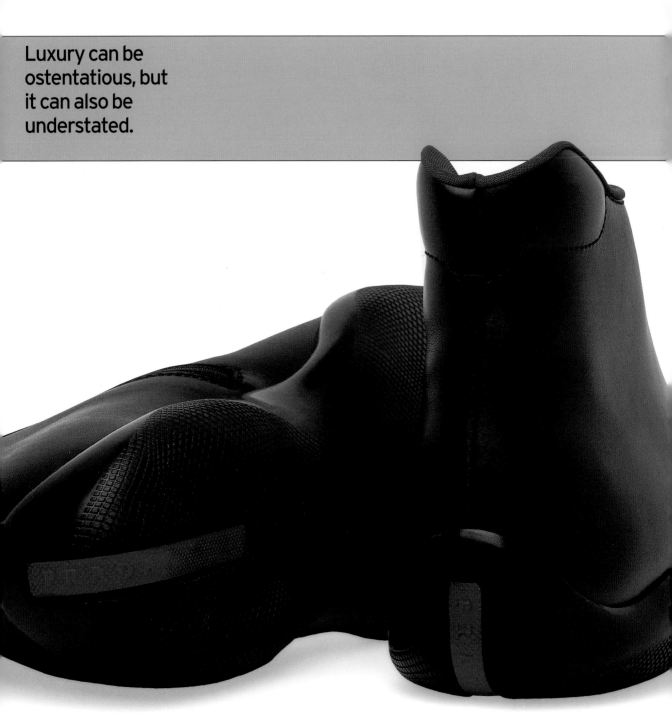

Luxury can be
ostentatious, but
it can also be
understated.

Prada

Like many Italian fashion brands Prada, founded in 1913, was originally a leather goods manufacturer and its reputation lies in the craftsmanship of the leather bags and accessories that still provide the backbone of its range. In the 1980s family heiress Miuccia Prada took control of the company and introduced fabrics like military-standard nylon (the characteristic and much copied material of the standard Prada tote bag), modernising the products and injecting a contemporary urban edginess into the brand.

Unadorned simplicity is at odds with conventional elite design but basic, primary colours and shapes typify Prada products. If anything, Prada is anti-status. By a curious tautology, the discerning consumer – the fashion cognoscenti – recognises that this actually confers status. Just as Prada colours are muted, so too labelling is discreet. Prada consumers are connoisseurs who recognise that 'less is more'. Luxury can be ostentatious, but it can also be understated.

Prada men's shoes, c.1999
V&A Photo

Cadbury

We must believe we are getting the best quality from luxuries, even if we are buying something that is inexpensive and widely available, like chocolate. Luxuries need not be expensive but they must promise an extra-special experience, a treat or an indulgence.

A look at this packaging shows how the brand celebrates and builds upon its own history to convince us of its quality. Dairy Milk chocolate was launched by Cadbury in 1905 and the wrapper has been purple and gold since 1920. The Cadbury's script logo was introduced in 1921 and was based on the signature of William A. Cadbury, chairman of the company. In 1928 a poster campaign claimed there was 'A Glass and a Half of Full Cream Milk in every half pound' of Cadbury's chocolate. Since the 1960s the device has been used on packaging to suggest the richness, healthiness and freshness of the product.

For early twentieth-century modernists, 'chocolate-boxy' was a term of derision for anything sweet, sentimental and luscious. Today we are not so dogmatic. Chocolate is often given as a gift and is associated with festivals such as Christmas and Easter – but more frequently it is bought as a personal treat.

1

2

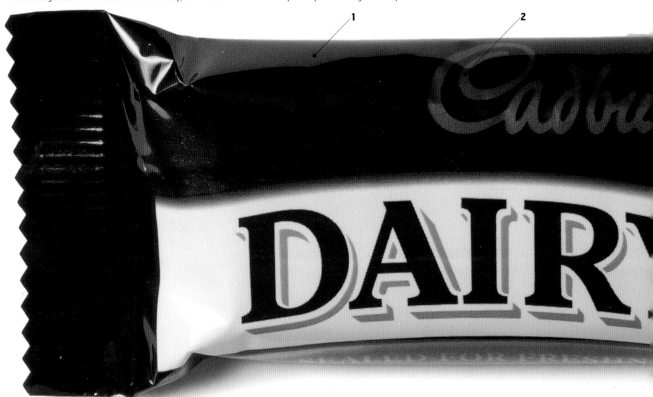

Luxuries need not be expensive but they must promise an extra-special experience, a treat or an indulgence.

1. In the past, purple was an expensive pigment to produce so it became the colour of imperial majesty. Because of this it now suggests luxury and status.

2. A name script like this not only personalises the product but suggests nostalgia for a bygone age.

3. The wrapper seems to be melting around the chocolate chunk, visually suggesting the sensation of eating it ourselves.

Cadbury's Dairy Milk packaging, 1999.
© Cadbury.

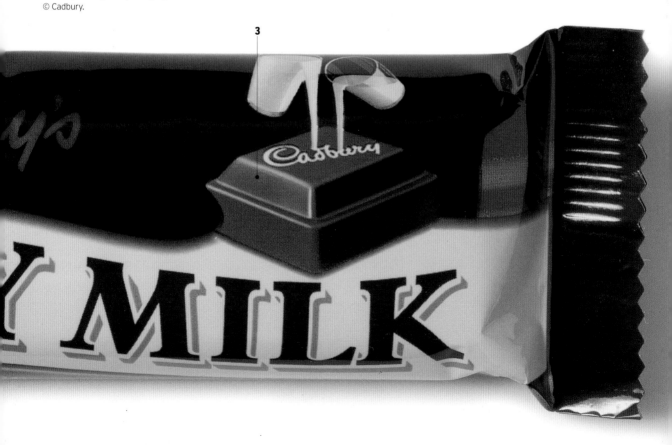

Marilyn Monroe reputedly claimed to wear nothing in bed but Chanel N° 5.

Chanel

Fashion brands now routinely produce scents that are made under license but which carry the brands' identities. Perfumes are a highly profitable way of extending a clothing brand into related body and beauty-oriented products. They are also loaded with hedonistic, sexual symbolism that supports the values of an indulgent luxury brand. Marilyn Monroe reputedly claimed to wear nothing in bed but Chanel N° 5.

The perfume was introduced in 1921 by the legendary couturier Coco Chanel and named after her lucky number. She even designed the packaging which remains fundamentally unchanged. It was an early example of a fashion brand successfully translating its values from clothes into other products intended for a relatively mass market. At the time of its inception Chanel was seen as a radical, modernist designer who liberated women's appearance. Her avant-garde modernist principles were expressed in the severe, almost pharmaceutical bottle that time has rendered classic rather than confrontational. The purity and timelessness of Chanel N° 5 does not detract from its luxury, but adds to its recognition and to the reputation of the brand.

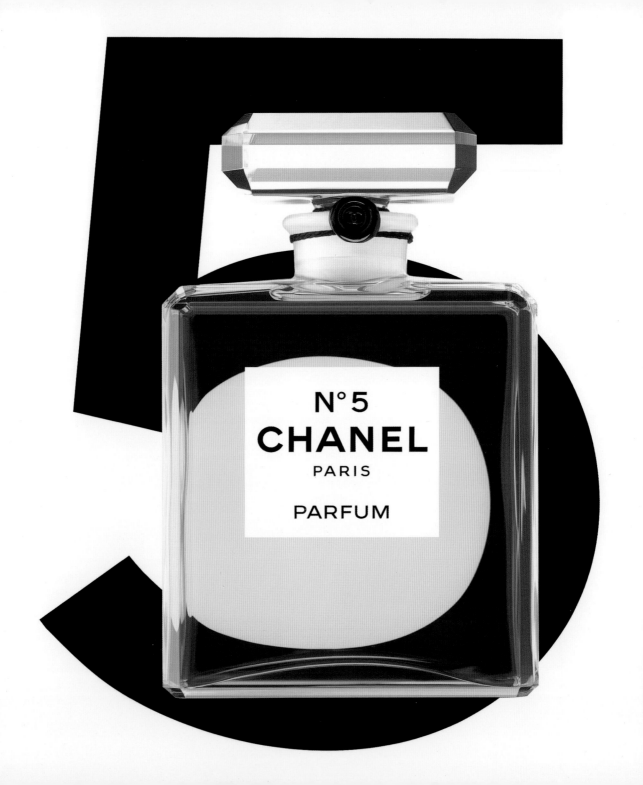

Versace

Classical decoration is a signifier of acceptable good taste and refinement. People who wish to show their high social status may favour it.

Luxury n. & a. (Habitual indulgence in) choice or costly surroundings, possessions, food, etc.. A means or source of luxurious enjoyment; spec. something desirable for comfort or enjoyment, but not indispensable. (OED).

Highly ornate and ornamented objects are more conspicuous than plain and undecorated products, and because they often cost more to make they are also a visible display of wealth. At times we use expensive brands to let other people know that we are rich enough to indulge our expensive tastes.

Classical style is associated with established power and wealth. Banks, ministries and museums are often classical buildings and represent institutional authority. Classical decoration, therefore, is a signifier of acceptable good taste and refinement. People who wish to show their high social status may favour it.

Fashion designer Gianni Versace developed highly ornate classically inspired patterns for the clothes, accessories and homewares bearing his name. Greek key patterns, c-scrolls, foliate swirls and the masks of gods are particularly prevalent. They indicate a classical decorative repertoire that many consumers regard as exquisite taste, while the gold detailing and rich colours tells us these are luxurious products.

The values of the Versace brand are relayed through the recognisable decorative style applied to each product. Such excessive decoration renders this plate barely usable, supporting the notion that luxuries are not indispensable necessities.

Medusa plate, Versace Home Collection
© Versace/Foto Caggi

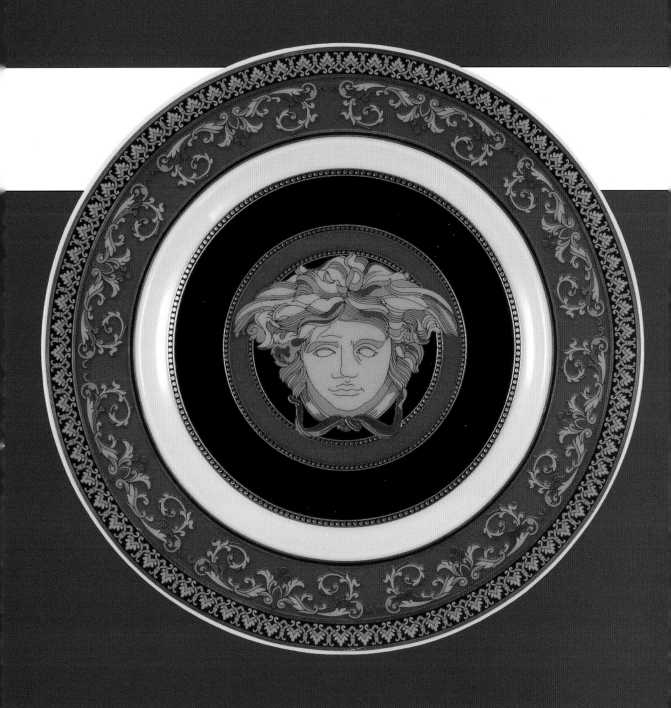

'It is a product you need.
But more than that, it
is a beautiful object that
you desire.'

Nokia

1. Luxurious products often emphasise the care with
which they are made and the quality of the materials
or ingredients. Fine craftsmanship and the best
materials cost money.

2. The mirrored case is an innovation in phone design.
It makes the 8810 seem like a powder compact, a
perfume bottle, or a cigarette case. It is both a tactile
object and one you will handle with care. Is it too
special to use? Perhaps it should stay in its box?

3. 'Like a fine watch or a fountain pen, the Nokia 8810
is a product you need. But more than that, it is a
beautiful object that you desire.' (Frank Nuovo, Chief
Designer, Nokia Mobile Phones.) Here the phone is
presented to us as an indulgence, a gift, or a treat like
chocolates. The ad tells us nothing about its
technological performance or efficiency, but appeals to
our desire.

4. Truly exclusive products are often individually
packaged in a way that will present them at their best
when the box is opened. The use of gold and ribbon
tells us the box contains something extra special.
Jewellery and perfume might be boxed like this, as well
as high quality confectionery.

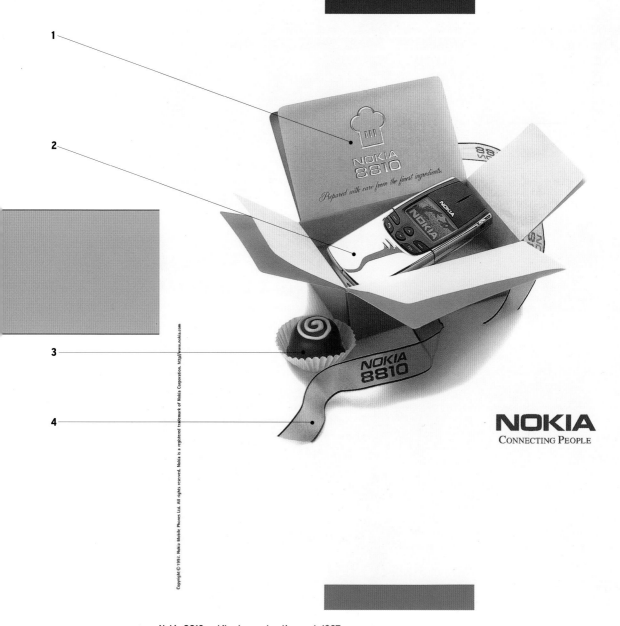

Nokia 8810 mobile phone advertisement, 1997
© Nokia Mobile Phones Ltd. 1997.
Art Director, Jari Peltonen. Photographer, Hans Kissinger.
Agency SEK & GREY

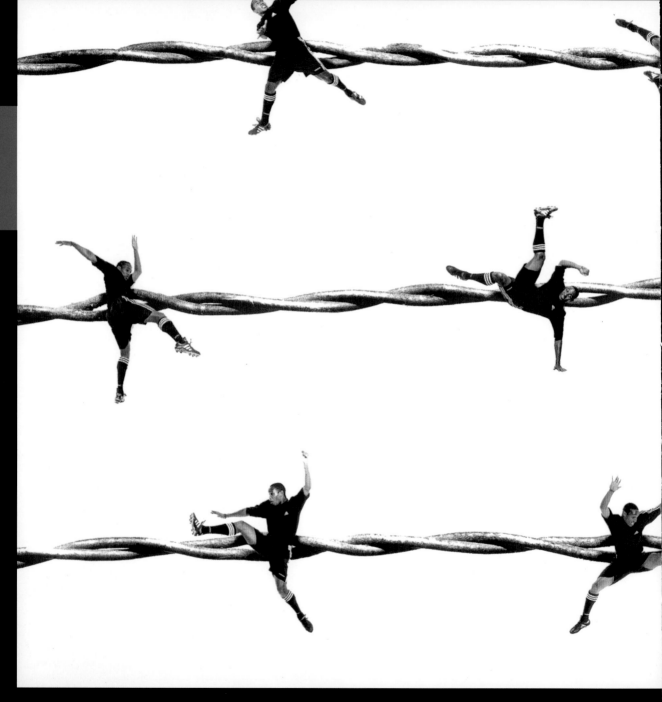

'We make a mean team my adidas and me.'

adidas

The German company adidas began in the 1920s as a producer of performance running shoes, and its reputation remains based on high-quality sports footwear. The three stripes of the logo, first applied to footwear in 1949, suggest both directional chevrons and the shape of sports shoes themselves. Like many rivals adidas uses celebrity sports stars to endorse its brand, with the effect that it becomes an aspirational, lifestyle label as well as a supplier of professional-quality sports equipment. In this image the England and Liverpool Football Club player Paul Ince is styled as barbed wire to advertise adidas Predator® Traxion® football boots. The combination of the product name, the aggressive imagery, and the reputation of Ince suggests the hard-hitting power the brand promises to bestow on us.

Sports footwear has entered mainstream fashion. In their 1984 hit 'My adidas' the rappers Run DMC sang that they "like to flaunt 'em, that's why I bought 'em... We make a mean team my adidas and me", making a clear connection between personal identity based on style and the brands that supply that style.

adidas Predator® advertisement
© adidas/Leagas-Delaney

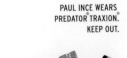

PAUL INCE WEARS
PREDATOR® TRAXION.
KEEP OUT.

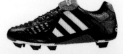

Microsoft

IT brands promise to give us shortcuts to sources of knowledge we could not reach before, and the brands that control channels of information wield great power.

The advent of printing made possible the mass-circulation and standardisation of knowledge. Today the society that was, in part, created by the printing revolution is being revolutionised by information technology, serviced by new businesses and industries. IT brands promise to give us shortcuts to sources of knowledge we could not reach before, and the brands that control channels of information wield great power.

Microsoft has become one of the most influential companies in the information technology revolution by publishing software which is the interface between people and their computers. Its slogan, 'Where do you want to go today?', invites us to think of computer technology as a new landscape and Microsoft as our guide through it.

The computer encyclopedia Encarta is the conflation of computer technology and our desire for knowledge. It is the embodiment of the potential for IT to transform society through access to knowledge, and of Microsoft's determination to be the leading brand in the IT revolution.

Microsoft Encarta advertisment, 1999

It is as if the shapes constitute a new language; a new semantic for the PlayStation generation.

PlayStation

A way of defining a brand is to say it is the relationship of trust and reliance that develops between a manufacturer and its customers. Synergy between the brand and the consumer ensures its success. Brand owners want their brands to become our life-blood.

PlayStation is the computer gaming brand of Sony, the Japanese electronics and entertainment corporation. Launched in 1995 in Britain, PlayStation not only makes the hardware for running computer games at home but publishes games as well. Computer gaming has broken free of the teenage boy ghetto where it originated, but has maintained the close association with its core consumers' lifestyles. The controls of a PlayStation console are four buttons: a circle, a square, a cross and a triangle. Through these symbols the virtual worlds of all PlayStation games are accessed. It is as if the shapes constitute a new language; a new semantic for the PlayStation generation. The symbols also act as a logo for the brand. In this advertisement the PlayStation symbols resemble blood cells – a metaphor for the way the brand is internalised by its consumers.

PlayStation advertisement: 'Blood', 1999
© Sony Computer Entertainment Inc.
PlayStation is a registered trademark of
Sony Computer Entertainment Inc.

Caterpillar

Fashion brands build stories about themselves to engage with us. Caterpillar® advertisements show independent people surviving real life - there is no element of whimsy. Cities are increasingly the same internationally, and this ad suggests that Caterpillar® is the uniform of modern globetrotters as they negotiate their way through the metropolises defining the contemporary world. Here we find a Kenyan in Kawasaki, Japan.

Street fashion today looks like survival kit for the urban jungle and is made of materials developed for extreme sports and the military. Multiple pockets, flaps and easy access fasteners mean we can carry all our essentials (our mobile phones and credit cards, for example) strapped to our bodies. The gritty side of urban living - the back street, not Bond Street - is glamorised. We can all be urban warriors, expressing our independence rather than high-class status, and travel anywhere.

The Caterpillar® name is licensed from the American builder of construction industry equipment, assuring its authenticity as a brand connected to the dirty side of urban reality. There is no space for decoration or sentiment in this hard world and the clothes stress function over ornament. The impression we have is that Caterpillar® will enable us to cope with the knocks and alienation of modern life.

Caterpillar advertisement: Kenyan in Kawasaki, 1999
© Overland Group Ltd
Concept & Art Direction: Shubhankar Ray
Photography: Stefan Ruiz
© 1999 Caterpillar Inc. Caterpillar® and Cat®
are registered trademarks of Caterpillar Inc.

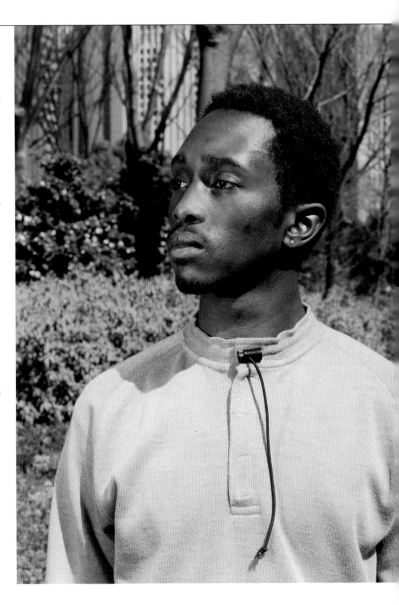

There is no space for decoration or sentiment and the clothes stress function over ornament.

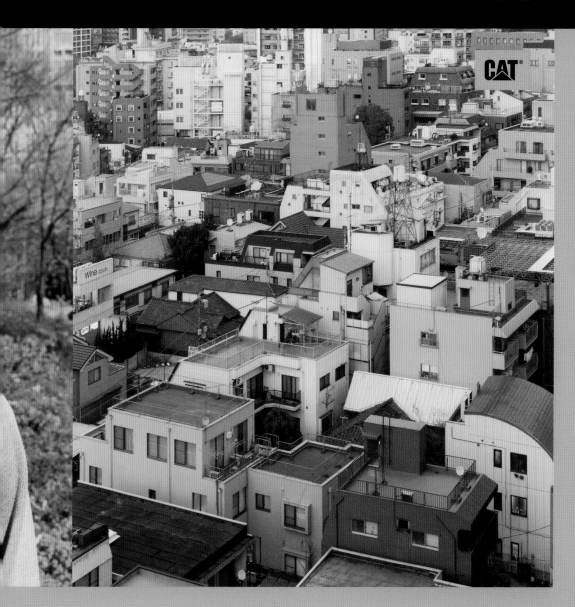

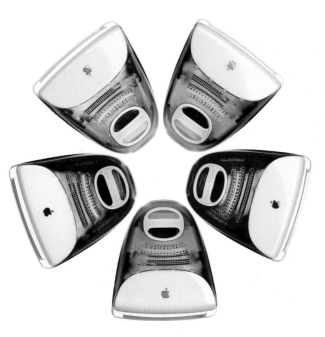

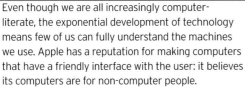

Apple

Even though we are all increasingly computer-literate, the exponential development of technology means few of us can fully understand the machines we use. Apple has a reputation for making computers that have a friendly interface with the user: it believes its computers are for non-computer people.

Apple demystifies computers in two ways. The grey housings are disregarded by many manufacturers who concentrate their efforts on the functionality of the technology inside. In contrast, the dazzling, jewel-like styling of Apple products are more decorative and appealing than their monochrome competitors. Through product design the brand promises an emotional, rather than merely technical, relationship with the product. Additionally, the high-specification technology inside the machine is designed not to

daunt the user. The i-Mac is pre-fitted with gadgets that, until recently, needed to be fitted externally; for example, a modem for internet access. We don't need to know how it works.

The entire Apple range, from laptops to large professional machines, has been redesigned to co-ordinate with the aesthetic of the i-Mac. The effect has been to draw the computer market closer to the fashion system, where products are defined as much by their looks as by their functionality. Computer hardware was a functional necessity; with the i-Mac it became a fashion accessory.

Apple computer products
Reproduced by kind permission of Apple Computer UK Limited.

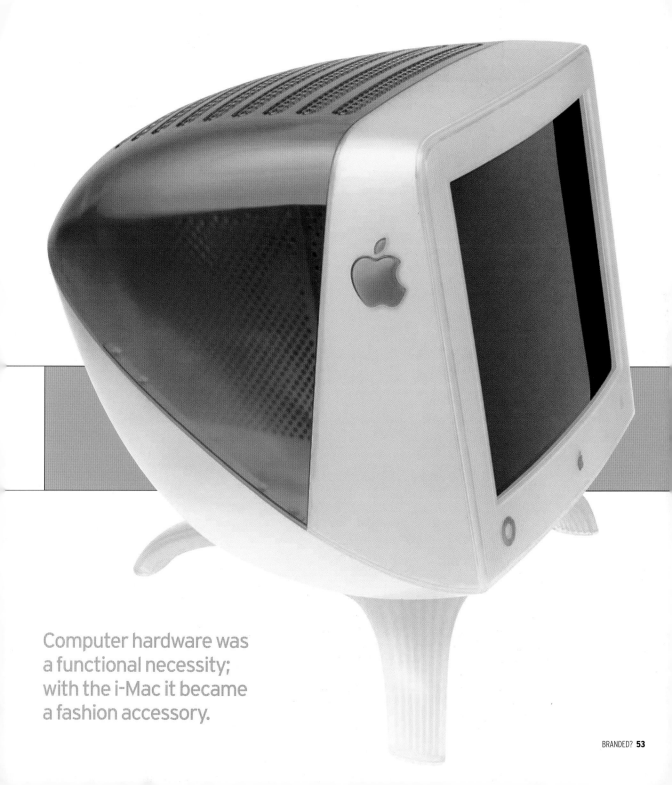

Computer hardware was
a functional necessity;
with the i-Mac it became
a fashion accessory.

If brands are about promises,
then Diesel makes ludicrous,
comical promises.

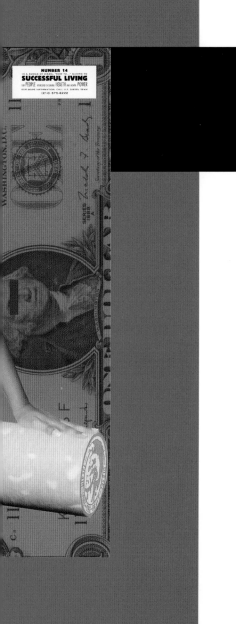

Diesel

'Man, who needs two lungs anyway?' asks this advertisement for Diesel, the cheeky Italian fashion company. Well, clearly, we do, especially if we are to learn the art of successful living, which is the promise made by Diesel. This is a postmodern brand because it regurgitates sources for its clothes, advertisements and shop interiors scavenged from twentieth century popular culture. It is an Italian brand masquerading as an American brand, mixed with a healthy dose of Europop.

In this context, successful living is about irony. Being in on the joke and having a prior understanding of the conventions of taste, culture and even the mechanics of branding itself, is essential for the consumer to appreciate Diesel. If brands are about promises, then Diesel makes ludicrous, comical promises to its consumers that highlight the superficiality of all brand messages. It simultaneously ridicules clichés (sexy girls, money, 'how to...' guides) and the political correctness that banished the benefits of smoking from advertising. Diesel is always rebellious and irreverent, seeking to appeal to free-thinkers and independent souls. However, there is one cliché even Diesel cannot resist. Its models are always gorgeous and so, like all fashion brands, Diesel carries the promise of sophistication and sex appeal.

Diesel 'Successful Living' campaign, number 14. 1993
© Courtesy of Diesel

The brand is kept highly
visible because it often makes
contrary statements about
the fashion industry.

Benetton

Campaigns by the Italian clothing company Benetton,
under the guidance of its art director Oliviero Toscani,
have redefined advertising. Benetton clothes are
conventional, but the image the company promotes of
itself is provocative and often controversial. The brand
is kept highly visible because it often makes contrary
statements about the fashion industry. In 1984 Toscani
initiated the 'United Colors of Benetton' slogan,
allowing the brand to be inclusive of ethnic, cultural
and other diversity. The most famous Benetton
campaigns have not featured its clothes at all, but
have prompted media and public attention, even
outcry, with images of the dying and the new-born.

This image is drawn from a 1998 Benetton
campaign featuring children with Downs Syndrome.
Their distinctive appearance is counter to typical ideals
of beauty and health formulised by the fashion
industry. By commenting on conventional truths
contained within branded messages and questioning
our preconceptions, the brand appeals to the
discernment and intelligence of the consumer.

Benetton Sunflowers campaign, Autumn/Winter 1998
© O. Toscani/Benetton.

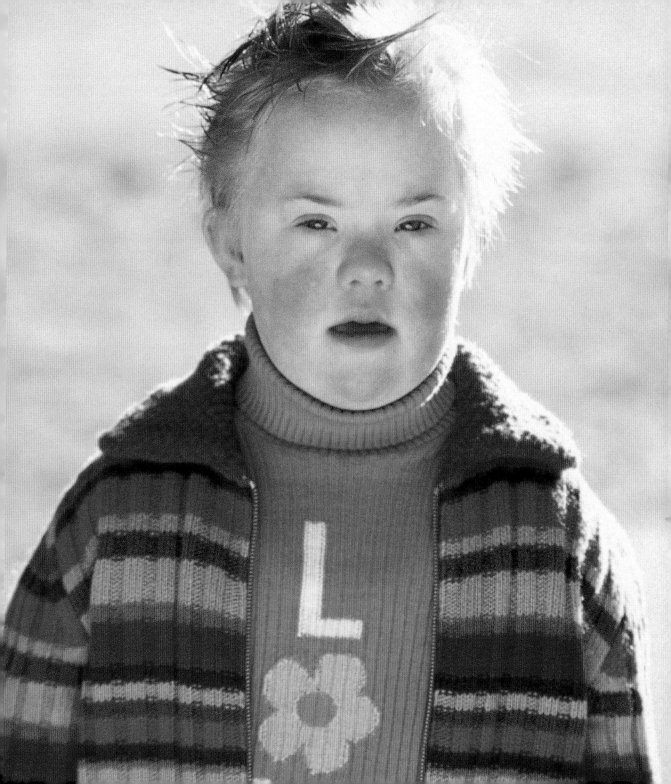

Tango

Brands sometimes mimic or mock their rivals as a way of defining themselves in crowded markets. Tango's principal target market is the highly volatile – and valuable – appearance-conscious 13-24 age group. These kids are acutely aware of the nuances between products and adopt irreverent, cheeky brands in tune with their sense of humour and their lifestyles.

Tango advertising has been the major vehicle for the brand's values. Its ads are often mischievous and appeal to practical jokers; from 1992 the long-running 'You've been Tango'd™' campaign featured characters startling ordinary drinkers with surprise slaps and kisses, and introduced a new phrase to the English language. Apple Tango campaigns light-heartedly compare the product's allure to the temptation of illicit and deviant sex. The explosive Tango logo expresses the brand's larger-than-life personality.

In this advertisement from the summer of 1999, the target of fun is rival brand Lilt, a tropical fruit-based drink made for the British market by Coca Cola since 1970. (Originally made in the 1950s, Tango has been made by Britvic since 1986.) For many years the Lilt advertising campaign promised a "totally tropical taste". This advertisement impersonates Lilt campaigns while subverting them: the can is presented as a stereotypical English tourist without the glamour of the models who generally populate tropical beaches in advertisements. The lampoon is reinforced by the inclusion of the tongue-in-cheek disclaimer inviting the viewer to think of other soft drinks.

Tropical Tango advertisement, 1999
© HHCL & Partners/Britvic Soft Drinks Ltd, 1999.

These kids are acutely aware of the nuances between products.

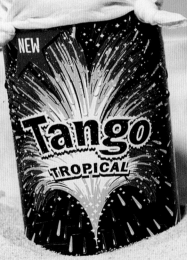

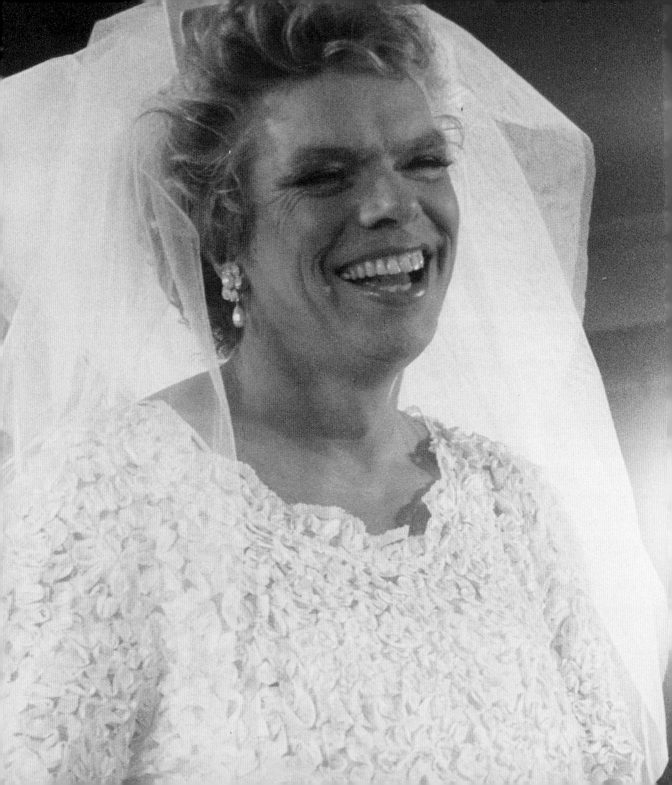

Virgin has always tried to subvert the norms of established products and services.

Virgin

The Virgin brand began as a record label founded by Richard Branson. Perhaps because rock music is by definition rebellious, Virgin has always tried to subvert the norms of established products and services. Virgin markets its own cola, vodka and clothes, operates financial, rail, internet and telephone services, and famously took on the mighty British Airways with its transatlantic airline. It shows how a single brand identity can cross boundaries to be associated with diverse types of product. How does it achieve this?

The chief mechanism for the diversification of the Virgin brand is the personality of Richard Branson himself. He is presented as a kind of 'Everyman', with the best interests of us, his consumers, at heart. He personalises what could otherwise be a faceless corporation, gaining our trust along with our custom. Branson keeps the Virgin brand constantly in the public eye with his personal pursuits, such as ballooning, that reinforce the non-conformist values of the brand itself. Here Richard Branson is pictured to launch the bridalwear store Virgin Brides in 1996. Which other global entrepreneurs would publicise their new venture so irreverently?

Virgin Brides advertisement, 1996
© Virgin

For football fans loyalty means earning a sense of ownership in the club.

Manchester United

While football matches last only ninety minutes, through merchandise fans can live out their obsession with the game twenty-four hours a day. A strong brand builds loyalty from its consumers, just as a football team inspires loyalty from its fans. For football fans loyalty means earning a sense of ownership in the club, sharing the heartache of defeat and the ecstasy of victory. Loyalty is about belonging.

The communications revolution means that fans are no longer concentrated in the localities, or even the nations, of major league football teams. Manchester United has a huge and growing fan base in China, for example, who can share the fortunes of their team and the passion of their fellow supporters through televised matches, websites, 'fanzines' and merchandise. The merchandise identifies the supporter as part of a recognised tribe of other fans, and allows his passion for the game to permeate every waking (and sleeping) moment.

Manchester United merchandise, 1999
© Manchester United Merchandising Ltd

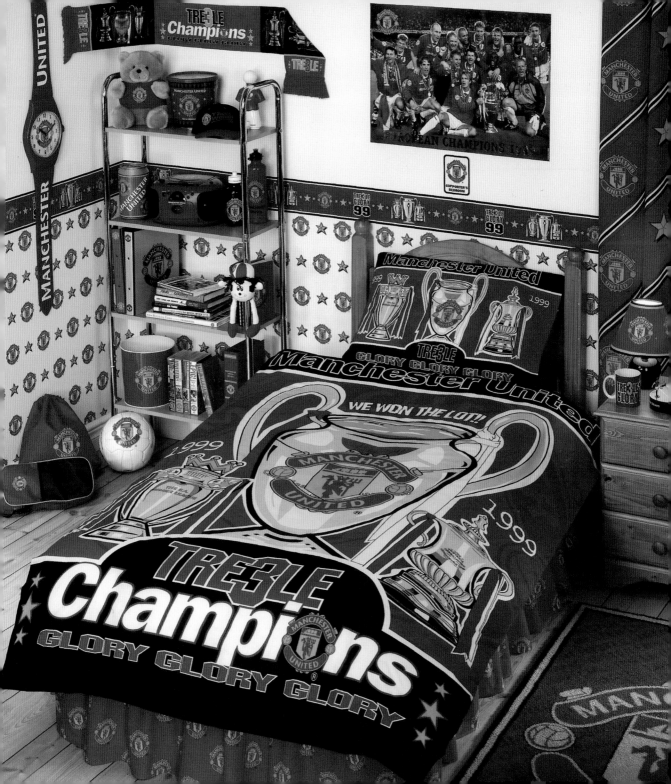

Hello Kitty

Stories can give brands life. When the Japanese company Sanrio created Hello Kitty in 1974 they claimed the character was born in London weighing three apples, the daughter of an airline pilot and a concert pianist. Since then her image has appeared on thousands of Sanrio products and is licensed to enhance goods made by other companies. It is possible to own Hello Kitty merchandise for every activity in your life, from confectionery to cars.

1. In Britain Hello Kitty has been appropriated ironically by club culture. These T-shirts are marketed by high street fashion store Top Shop. Hello Kitty is entering the mainstream British consciousness.

2. Hello Kitty is principally designed to appeal to children, but not all the products are toys. This is a real grill that actually brands the toast with the face of Hello Kitty!

3. Placing a recognisable brand on a simple or mundane product adds value, both symbolically and financially. Hello Kitty is non-specific and can be used on all kinds of merchandise.

4. In Japanese culture the figure of a cat is a lucky emblem often displayed outside restaurants and other businesses. Hello Kitty is gregarious and has many friends, also created by Sanrio.

5. Sanrio has partnerships with Sanyo and other Japanese consumer electronics manufacturers. The combination of two leading brands in one product means that it has an even greater chance of succeeding in the market place.

Hello Kitty is a vehicle to promote merchandise. These products create an entire lifestyle for avid collectors. They are also intended to be given as gifts – an important and formalised system that traditionally binds Japanese society. The brand promises to deliver happiness.

© 1976, 2000 Sanrio Co. Ltd.

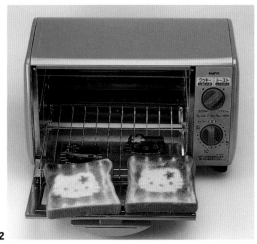

1

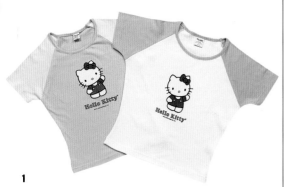

2

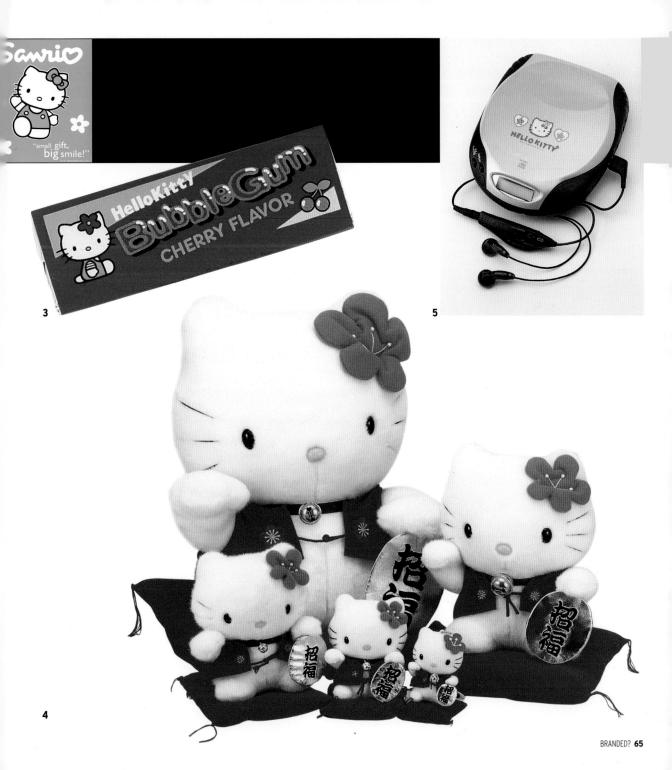

3

4

5

Disney has introduced a new word to the English language - imagineering.

Disney

The power of imagination lies at the heart of the Disney brand: our desire for entertainment is satisfied by Disney's ability to deliver products and places that entertain us. The company has introduced a new word to the English language - imagineering - which is the alchemic process of making imagined fantasies into real life. Disney products range from movies through merchandise to its famous theme parks. At Disney theme parks, entertainment and imagination are assured. They are wonderlands where we can live out the fantasies of Disney movies.

In the movie *Who Framed Roger Rabbit* animated characters lived in a cartoon place called Toontown. The film mixed animation with live action and the same effect was recreated at Disneyland Park in California in 1993 with the opening of a new attraction, Mickey's Toontown. Every detail of the town, from the post boxes to the gas station, was recreated life-size. It is as if a cartoon has come to life, immersing us in the experience of being in an animated adventure: for a moment we can live in a fantasy. Our imaginations are both stimulated and managed by Disney.

Goofy's Gas, Mickey's Toontown
© Disney Enterprises, Inc.

Lara Croft

The simulation of reality can be more real than the real thing.

Computer games are windows into virtual worlds, and perhaps it is only human that we create near-human guides to lead us around cyber-space. For without them, how will we know where to go and what is 'real'?

Lara Croft is the most iconic guide in this super/supra-human environment. She exists as a brand in her own right alongside Tomb Raider, the (branded) game in which she acts out her adventures. Lara stands out as a woman in a world until now dominated by men and monsters. Her perfect physique, tireless stamina, prowess and courage are all qualities that we used to find embodied in movie stars. Unsurprisingly they may also be qualities we wish to find in ourselves. 'Real' women are increasingly modelled to emulate the values of Lara, such as the fearless 'girl power' of The Spice Girls, or the 'Bond girl' Christmas Jones in the film *The World Is Not Enough*.

Lara's adventures on the small screen simulate active experiences for the passive player. Computer-generated worlds can be more absorbing, more challenging, even more 'real' than the actual world we live in. In the terms of French philosopher Jean Baudrillard, they are simulacra – the simulation of reality itself, more real than the real thing.

Lara Croft
© Eidos Interactive Ltd/Core Design Ltd

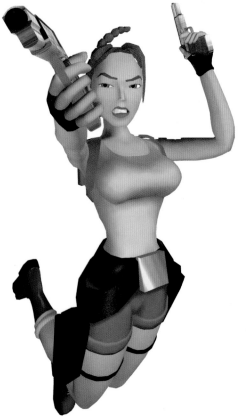

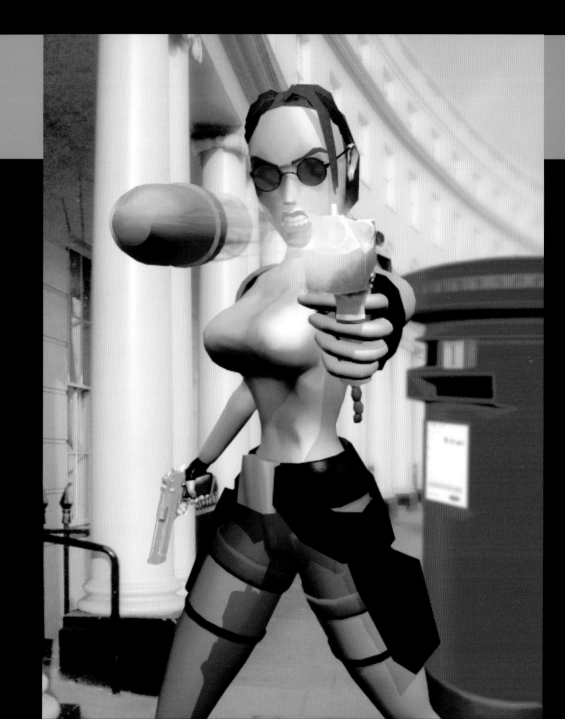

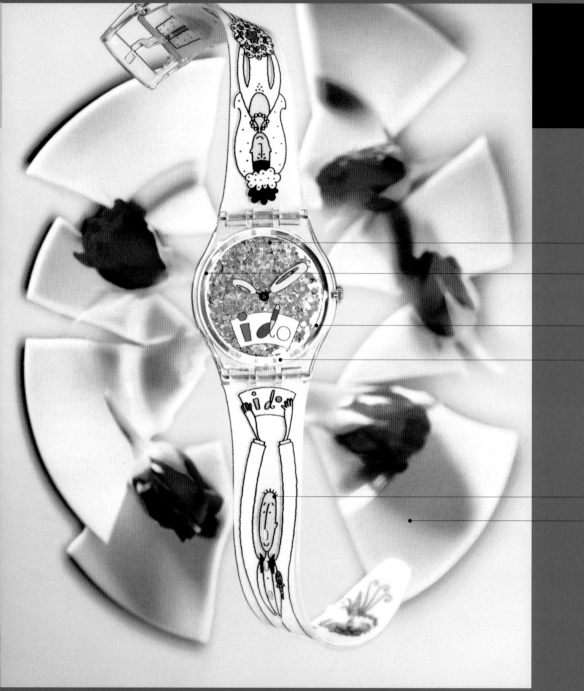

1

2

3

4

5

6

Swatch

1. Swiss watches are traditionally a byword for quality, taste and accuracy. Swatch developed mass-produced watches from the 1980s to counter the challenge faced by Swiss makers of cheaper watches from the Far East.

2. The shape of the face and the materials instantly identify Swatch. The simplicity of the form unites the range, even though each watch in a seasonal collection has different decoration.

3. The jokey decoration is more prominent than the brand name. Marital status has traditionally been a means of defining one's identity, but does the watch celebrate marriage, or mock it? Swatch is famous for its fun products and humorous designs. The joke itself identifies the brand.

4. We are more likely to talk about our 'Swatch' than about our 'Swatch watch'. The brand name has become a descriptive noun for this form of timepiece. As a result Swatch watches are widely copied, but Swatch keeps ahead of rivals by constantly editioning new models and withdrawing old ones.

5. The decoration of the watch is bright, cheerful, fun and frivolous. For these reasons it may not be something one wishes to wear every day. Swatch innovated by producing watches as fashion accessories, rather than heirlooms.

6. Swatch watches are generally affordable; however special editions, creative marketing and an avid collectors' market can make some models very expensive. Swatch maintains demand for its brand by tempting consumers with new models and controlling availability of some watches. Making collections of watches can be fun in itself.

White Wedding watch from Swatch Friends collection, Autumn – Winter 1999.
© Swatch AG, photo Nick Welsh

Frosties

Tony the Tiger is the personification of Kellogg's Frosties breakfast cereal. His antics embody the brand's values. Tony is strong, popular, athletic, and good fun to be with.

Branded characters often have catch-phrases that accompany their appearances. For the long-running Bisto kids who advertised gravy powder, the slogan 'Aaah, Bisto' referred to the smell of the product. Tony the Tiger tells us Frosties are 'Grrrreat!™'.

Tony the Tiger has been the brand character for Frosties since 1956. So familiar is his orange and black figure that sometimes only a part of his anatomy is shown, which is enough to conjure up the whole Tony in the mind's eye. Characters allow brands to maintain relevance as they can engage in the contemporary events that are pre-occupying their consumers. As the public went mad for football during the Euro '96 tournament, so Frosties ads showed only Tony's upraised paws brandishing his tail in the manner of a football scarf. Tony the Tiger befriends consumers by sharing their lives. Through Tony, Kellogg's distinguishes Frosties for its consumers.

Frosties advertisement 1996
© Tony the Tiger, 2000
Reproduced by kind permission of the Kellogg Company

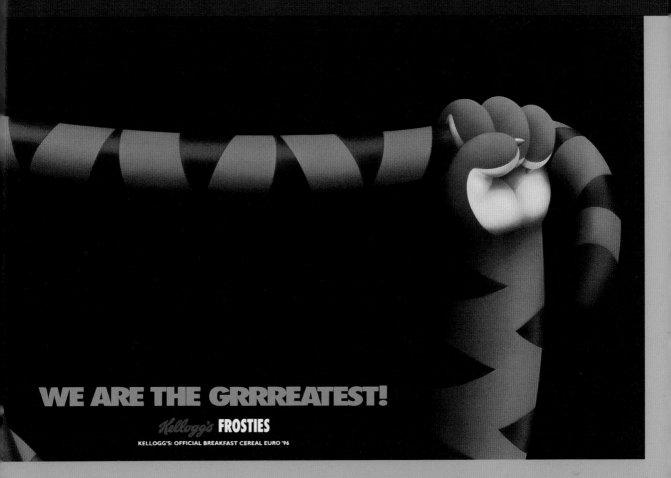

WE ARE THE GRRREATEST!

Kellogg's FROSTIES

KELLOGG'S: OFFICIAL BREAKFAST CEREAL EURO '96

The New Beetle is a revival of
the brand, rather than the
reintroduction of a product.

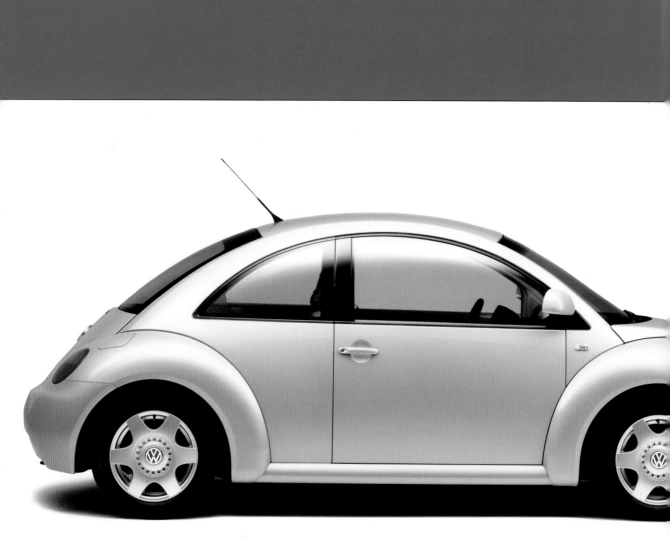

The New Beetle

Volkswagen is a brand with a reputation for reliability, and the Beetle is a sub-brand of VW. The New Beetle, introduced by VW in the late 1990s, is a retro design based on one of the most successful cars of the twentieth century. The original car was a basic people-carrier (Volkswagen means 'people's wagon' and was founded to mass-produce affordable automobiles), ensuring that it was adaptable for numerous uses and locations. The Beetle was easy to maintain and full of character. Later it was the car of choice for American hippies and Mexican taxi drivers; in fact, anyone who appreciated its durability. But not only was the Beetle reliable, it was fun.

The New Beetle is a revival of the brand, rather than the reintroduction of a product. The designers have tried to imbue the new car with the character of the old car – they have preserved its 'buginess'. The distinctive shape makes it stand out amongst the anonymity of contemporary car design. The Beetle was a vehicle conceived purely around function: The New Beetle is about style, nostalgia and individuality.

The New Beetle, 1999
© Volkswagen

We believe we can 'do our bit' vicariously, by buying products like this.

The Body Shop

When she founded The Body Shop in Britain in 1976, Anita Roddick aimed to create a cosmetics brand with a difference, built on environmentalist principles. Organic, natural products are perceived as both good for us and less harmful to the environment than alternatives. As rival brands have introduced competing organic products, so The Body Shop has increasingly differentiated itself by emphasising its social and human rights policies alongside its environmentalist identity.

The Body Shop appeals to our sense of community with people elsewhere in the world through fair trade policies and by promoting ethical tourism. The Body Shop's Eau No! range of travel products claims to lighten the impact of tourism on ecologically sensitive destinations.

Body Shop values - responsibility, fairness, stewardship of the earth - are values that appeal to the conscience and intelligence of consumers. The authenticity of the tourist experience is emphasised; Eau No! products are 'for places where water, not adventure, is in short supply'. We believe we can 'do our bit' vicariously, by buying products like this.

Eau No! Shaving Grace, The Body Shop, UK, 1999
Courtesy of The Body Shop International plc
© The Body Shop International plc

THE BODY SHOP

EAU NO!
SHAVING
GRACE

Gourmet Percol Coffee

1. Producers in fair trade schemes - in this case Latin American coffee growers - receive a fair share of profits for their work. More often profit would be reserved for the international corporations that market coffee.

2. The farm in the picture is fertile and productive. Fair trade schemes claim to give material benefits to third world farmers, relieving cycles of poverty by relieving exploitation.

3. Not only can this brand of coffee help the farmers, but it is also organically grown without chemical sprays or artificial fertilisers; so the earth also benefits if we choose to buy it. Social and environmental issues are often present together in brands that appeal to consumers' consciences.

4. The illustration of happy farmers gives consumers a direct emotional point of contact with the product. We are encouraged to think, 'by buying this coffee I am helping these people'. Fair trade brands often include illustrations of, or information about, the people that make them and who benefit from our purchase.

5. The Fair Trade Foundation is an independent organisation of charities, distributors and manufacturers who guarantee to protect the rights of producers in the developing world.

6. This is a relatively unknown brand of coffee compared to its larger rivals. But it is endorsed by an official body, the Soil Association, reassuring consumers that it makes genuine claims about its quality.

Gourmet Percol Fairtrade Latin American Organic Arabica Coffee packaging
V&A photo

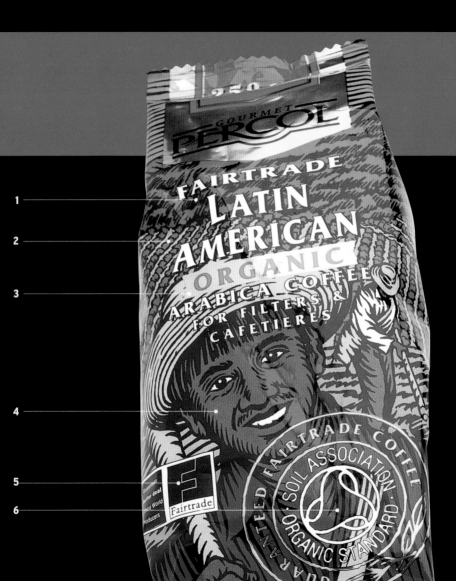

1

2

3

4

5

6

GOURMET
PERCOL

FAIRTRADE
LATIN
AMERICAN
ORGANIC
ARABICA COFFEE
FOR FILTERS &
CAFETIERES

Fairtrade

GUARANTEED FAIRTRADE COFFEE · SOIL ASSOCIATION · ORGANIC STANDARD

The Co-operative Bank

We can express our ethics through the ways in which we choose to invest or spend our money. The Co-operative Bank not only promises to invest our money wisely and securely (as does every other bank), it also promises not to use our money for purposes we do not agree with. In this advertisement the bank pledges not to invest in companies that pollute the environment, a message reinforced with engaging images of a clear summer day. Another ad in the same series condemns investments in oppressive regimes.

The inference is that the bank is in tune with its customers and shares their values and concerns. This contrasts with the position in which Barclays Bank found itself during the 1980s, when it was boycotted over its investment in apartheid-era South Africa.

Most investors are primarily concerned about the security of their money and the level of return they will get. Ethical banking, however, appeals to a niche market of investors who have additional priorities.

Advertisement for The Co-operative Bank, 1999
© Simon Green/Partners BDDH

The inference is that the bank is in tune with its customers and shares their values and concerns.

The C⊙OPERATIVE BANK

After all, it's your money

I love this

The sky, the grass, the trees, the sky, the river, I love it

The way it is

The Co-operative Bank will never invest its customers' money in companies who needlessly pollute the environment. It's part of an ethical policy that states what we will and won't do with your money. After all, it's your money.

0800 90 50 90

www.co-operativebank.co.uk

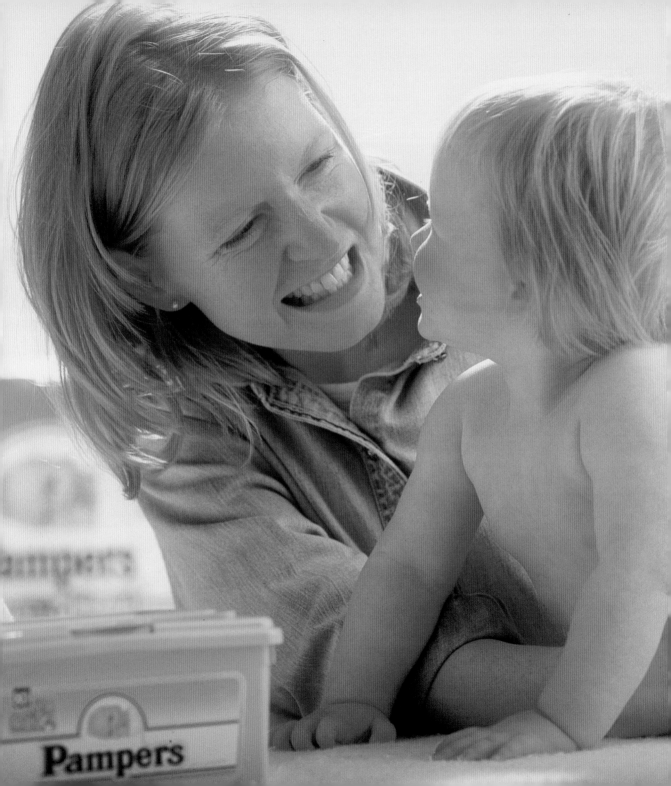

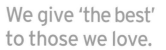

We give 'the best'
to those we love.

Pampers

Babies and small children are unable to be direct consumers of brands, so their parents make choices on their behalf. The values that are expressed by baby-care brands reflect the parents' relationship with the child: love, care and responsibility.

We may often equate giving something that is perceived to be 'the best' with our desire to look after those we love. This is different from indulging our children with treats: it is a manifestation of the deep human emotional drive towards caring and nurturing. The best baby-care products are translatable as the best expressions of love for a child.

Pampers is the leading brand of disposable nappies in the UK, with sales over double that of its nearest rival, Huggies. In advertising for Pampers the bond between mother and child is emphasised and the nature of the relationship is inferred by the brand name. Like any parent she intends to care for the baby to the best of her ability. The child is happy and fulfilled and the relationship is mutual and relaxed. But is it also suggested that, denied Pampers, the child would not be so comfortable, so fulfilled, so happy or so loved? Could our sense of responsibility become entangled with feelings of anxiety or guilt?

© Procter & Gamble/Picture Disc
Photographer: Duncan Davis

Barbie

Since she first appeared in 1959, Barbie has been one of the most popular toys ever produced. At first she was an all-American teenager: blonde, blue-eyed, popular and fashionable. Subsequent Barbie dolls reflected ethnic diversity in her market, including Afro-American and Latino models. Later, Asian and Indian Barbies appeared. Periodically Mattel updates the basic model of Barbie and the ethnic variations are generally differentiated through their skin tone, hair, eyes and of course their dress. However, at heart Barbie remains an embodiment of western consumerist values.

Such is the popularity of Barbie that she is not only produced as a plaything but as a highly prized collectable. The limited edition Golden Qi-Pao Barbie doll was made to celebrate the first anniversary of the hand-over of Hong Kong to China, which took place in July 1997. The Qi-Pao is a traditional dress that has become something of a national symbol for the Chinese, and especially for Hong Kong. By styling Barbie in this way Mattel appeals to the sentiments of the Chinese who are the largest emerging market for Western brands in the world. Is it ironic that her slight form should be the agent that unites the values of the west and the east?

Golden Qi-Pao Barbie doll and packaging, Hong Kong, 1998
V&A photo.

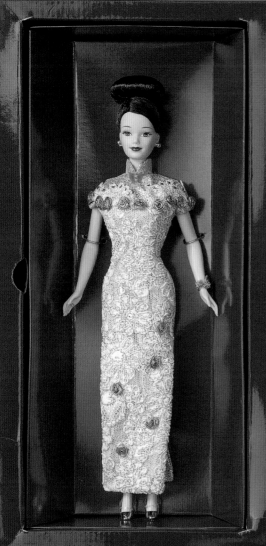

THE
QI-PAO
STORY

Barbie
COLLECTIBLES

Barbie
COLLECTIBLES

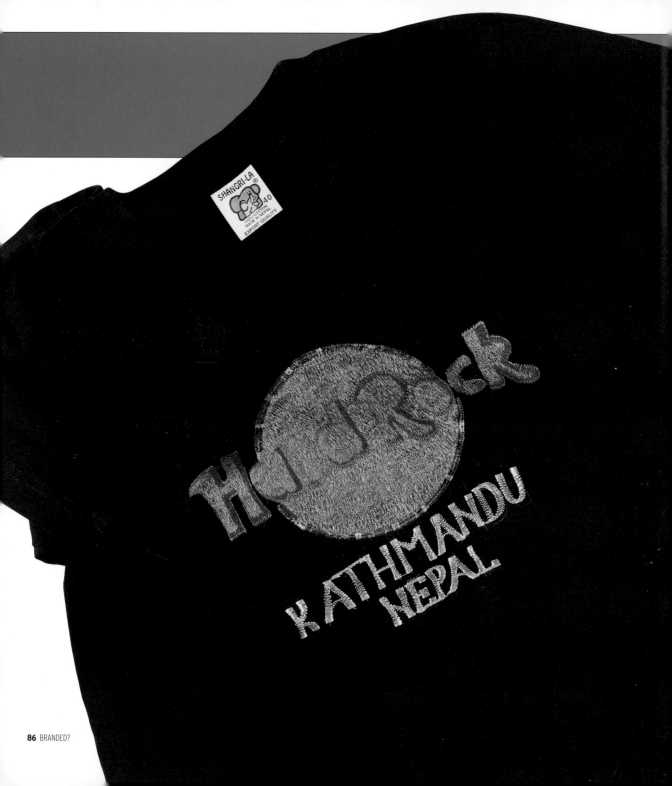

Hard Rock Café

Rock and roll has become an international soundtrack with few perceivable boundaries. The Hard Rock Café restaurant chain, founded in London in 1971, celebrates rock and pop music and attracts customers with collections of musical memorabilia, from concert posters to celebrities' instruments. The brand sells tourist experiences, and consumers almost always encounter it in an alien environment, away from home. The music may be the same wherever in the world the cafés are situated, but each one gains local specificity by selling souvenirs of its host city. In London these include Big Ben lapel badges, for example, which is a stereotypical sign of the city.

Hard Rock Café T-shirts reduce global differences to the name of the host city, while erasing every other trace of regionalism. Aficionados of the brand collect and trade the merchandise and T-shirts, and they are worn as signifiers that the wearer has travelled. They are both talismans and souvenirs. For international tourists the brand is an assurance of consistency with previous experiences, coupled with the attraction of the particular rock memorabilia housed in each restaurant.

Because of the popularity of the brand it is widely copied. Many cities have fake Hard Rock Cafés, or merely sell counterfeit goods unattached to a restaurant. This T-shirt mimics the style of the authentic product but because it is embroidered rather than printed, it shows it is locally produced. There is no Hard Rock Café in Kathmandu, Nepal, but an enterprising local business is endeavouring to profit on the international cachet of the brand and its recognition amongst the tourists who pass through.

Fake Hard Rock Café T-shirt from Kathmandu, Nepal
V&A photo

Irn-Bru

Along with whisky, Irn-Bru, made by the Glasgow company A.G. Barr since 1901, is quite possibly the national drink of Scotland. There its sales compete with the global soft drink Coca Cola. Although Irn-Bru is a rich and sweet drink made to a secret recipe from 32 ingredients, its powerful flavour and colour have associated the brand with masculine and doughty Scottish drinkers, who know it as 'Hubba Hubba'. Drinks cannot be named after ingredients they do not contain, but the distinctive spelling of Irn-Bru was introduced in 1946 before this legislation was enforced, and the drink is advertised today with the slogan 'made in Scotland from girders', further enforcing the brand's tough image.

Since its introduction in 1998, Irn-Bru has become something of a cult favourite behind the former Iron Curtain in Russia. There it is consumed as a mixer with vodka, much as it is drunk with whisky in Scotland. The economic crisis of 1998 persuaded foreign investors to withdraw from Russia but the makers of Irn-Bru persisted, enabling them to steal a march on competitors and sell fifteen million litres in 1999. The packaging, translated into Russian, replicates the Scottish product. Quite why Irn-Bru – a drink firmly associated with Scottish taste and character – strikes a chord with Russian consumers is a mystery. Maybe there is a synergy between two northern cultures; Glasgow and Moscow are perhaps not so far apart.

Irn-Bru advertisement, Russia 1998
© A.G. Barr

Along with whisky, Irn-Bru is quite possibly the national drink of Scotland.

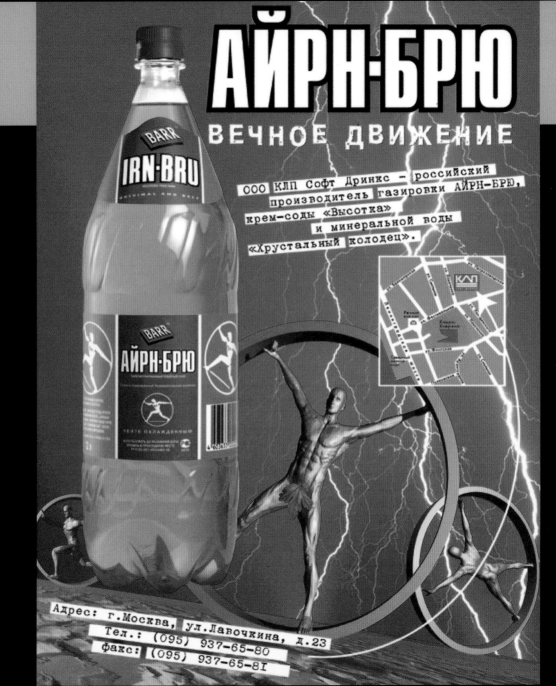

McDonald's

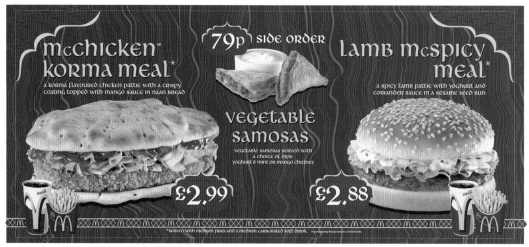

mcchicken™ korma meal*
a korma flavoured chicken pattie with a crispy coating topped with mango sauce in naan bread

£2.99

79p SIDE ORDER

vegetable samosas
vegetable samosas served with a choice of dips: yoghurt & mint or mango chutney

lamb mcspicy meal*
a spicy lamb pattie with yoghurt and coriander sauce in a sesame seed bun

£2.88

*served with medium fries and a medium carbonated soft drink. At participating restaurants for a limited time.

Speed, efficiency and service are the key McDonald's values. If the character of the early twentieth century was in part formed by the production-line standardisation developed by Henry Ford, then the standardised McDonald's burger bar represents the character of the latter part of the century. Just as Fords travelled all over the world, so we find McDonald's in every region, from Alaska to Japan, South Africa to Norway.

Yet we can't dismiss McDonald's as an entirely homogenous universal product, placeless and faceless in its uniformity. In each region the corporation assimilates local traditions into its all-embracing identity. Alongside its standard call of 'would you like fries with that?', McDonald's provides locally specific dishes interpreted through the expediency of instant service and gratification. So, while steak-loving Americans have their Big Macs™, the Japanese are served McTerikyaki™ Burgers and in India, where beef is taboo, the flagship of the menu is the lamb-based Maharaja Mac™.

This 1999 campaign for McDonald's played upon the British love of Indian food. Curry has replaced fish and chips as the national dish. The McChicken™ Korma Meal and the Lamb McSpicy Meal were accompanied by television ads in the manner of low-budget cinema ads for local curry houses, a genre familiar to British film-goers. In this way McDonald's assimilated a peculiarly British dietary custom itself imported from India.

Critics may dismiss this assimilation of world cultural difference as glib and condescending, yet it serves to give McDonald's a local identity and relevance while simultaneously allowing it to offer the authentic foreign (i.e. American) experience to consumers throughout the world.

Window posters, 'Curry and Spice' campaign
© 1999 McDonald's Restaurants Ltd
Creative by the Marketing Store worldwide

mcchicken™ korma naan

a korma flavoured chicken pattie with a crispy coating topped with mango sauce in naan bread

£1.99

lamb mcspicy

a spicy lamb pattie with yoghurt and coriander sauce in a sesame seed bun

£1.39

FURTHER READING

Appadurai, A., ed. *The Social Life of Things* (Cambridge, Cambridge University Press 1986)

Baudrillard, J. (trans. Ritzer, G.) *The Consumer Society: Myths and Structures* (London, Sage 1998)

Baudrillard, J. (trans. Foss, Patton and Beitchman) *Simulations* (New York, Semiotext(e) 1983)

Bourdieu, P. (trans. R. Nice) *Distinction: A Social Critique of the Judgement of Taste* (London, Routledge 1999); first published in French as *La Distinction: Critique sociale du jugement* (Paris, Minuit 1979)

Bowlby, R. *Shopping with Freud* (London, Routledge 1993)

Brewer, J., and Porter, R., eds. *Consumption and the World of Goods* (London, Routledge 1993)

Brown, S., and Turley, D., eds. *Consumer Research: Postcards from the Edge* (London, Routledge 1997)

Campbell, C., and Falk, P., eds. *The Shopping Experience* (London, Sage 1997)

Douglas, M., and Isherwood, B., eds. *The World of Goods: Towards An Anthropology of Consumption* (London, Allen Lane 1978)

Ewen, S. *All Consuming Images: The Politics of Style in Contemporary USA* (New York, Basic 1988)

Ewen, S. *Captains of Consciousness: Advertising and the Social Roots of the Consumer Culture* (New York, McGraw Hill 1976)

Featherstone, M. *Consumer Culture and Post Modernism* (London, Sage 1991)

Featherstone, M., ed. *Global Culture, Nationalism, Globalization and Modernity* (London, Sage 1990)

Fine, B., and Leopold, E. *The World of Consumption* (London, Sage 1993)

Forty, A. *Objects of Desire* (London, Thames and Hudson 1986)

Gabriel, Y., and Lang, T., eds. *The Unmanageable Consumer, Contemporary Consumption and its Fragmentations* (London, Sage 1995)

Goldman, R., and Papson, S. *Nike Culture, The Sign of the Swoosh* (London, Sage 1998)

Haug, W. F. *Critique of Commodity Aesthetics* (Minneapolis, University of Minnesota Press 1986)

Hebdige, D. *Hiding in the Light: On Images and Things* (London, Methuen 1987)

Hebdige, D. *Subculture: The Meaning of Style* (London, Methuen 1979)

Keat, R., Whiteley, N., Abercrombie, N., eds. *The Authority of the Consumer* (London, Routledge 1994)

Lash, S. *Economies of Signs and Spaces* (London, Sage 1994)

Lunt, P., and Livingstone, S., eds. *Mass Consumption and Personal Identity: Everyday Economic Experience* (Buckingham and Bristol, Open University Press 1992)

Lury, C. *Consumer Culture* (Cambridge, Polity 1996)

McCracken, G. *Culture and*

Consumption: New Approaches to the
Symbolic Character of Consumer Goods
and Activities (Bloomington, Indiana
University Press 1990)
Marling, K. A. Designing Disney's
Theme Parks: The Architecture of
Reassurance (Paris and New York,
Flammarion 1997)
Miller, D. A Theory of Shopping
(Cambridge, Polity 1998)
Miller, D., ed. Acknowledging
Consumption (London, Routledge
1995)
Miller, D., Jackson, P., Thrift, N.,
Holbrook., B., and Rowlands, M.
Shopping, Place and Identity (London,
Routledge 1998)
Mollerup, P. Marks of Excellence: The
History and Taxonomy of Trademarks
(London, Phaidon 1997)
Nava, M., Blake, A., MacRury, I.,
and Richards, B., eds. Buy This Book:
Studies in Advertising and Consumption
(London, Routledge 1997)
Pavitt, J., ed. Brand.New (London,
V&A Publications 2000)
Redhead, D. Products of Our Time
(London, August; Basel, Boston and
Berlin, Birkhäuser, Publishers for
Architecture 1999)
Rogers, M. F. Barbie Culture (London,
Sage 1999)
Sherry, J. Contemporary Marketing and
Consumer Behaviour (London, Sage
1995)
Shields, R., ed. Lifestyle Shopping
(London and New York,

Routledge 1992)
Sparke, P. As Long as It's Pink: The
Sexual Politics of Taste (London,
Pandora 1995)
Veblen, T. The Theory of the Leisure
Class: An Economic Study of Institutions
(London, George Allen and Unwin
1925)